Visual
design

Visual Design
Ninety-five things you need to know. Told in Helvetica and dingbats.

Jim Krause

New Riders
Find us on the Web at www.newriders.com
To report errors, please send a note to errata@peachpit.com

New Riders is an imprint of Peachpit, a division of Pearson Education.

Copyright © 2015 by Jim Krause

Acquisitions Editor: Nikki Echler McDonald
Production Editor: Tracey Croom
Proofreaders: Jan Seymour, Emily Wolman
Indexer: James Minkin
Cover Design and Illustrations: Jim Krause
Interior Design and Illustrations: Jim Krause

ISBN 13: 978-0-321-96815-9
ISBN 10: 0-321-96815-8

9 8 7 6 5 4 3 2 1

Printed and bound in the United States of America

Visual design

Ninety-five things you need to know.
Told in Helvetica and dingbats.

Jim Krause

VISUAL DESIGN

TABLE OF CONTENTS

5

INTRODUCTION

If I were to describe the intended tone of this book—both in terms of its text and images—I'd say it's meant to come across as concise, and also conversational; to-the-point, but not without its share of meandering anecdotes; and serious while still delivering hints of sass and humor. In other words, just the sort of passionate, focused (and sometimes playfully irreverent) tone you might expect when talking design or art with anyone who's similarly interested in creativity.

Visual Design is for designers, illustrators, photographers, fine artists, and pretty much anyone else involved in creating art for professional or personal purposes. This is a book that's filled with highly usable and widely applicable principles of aesthetics, style, color, typography, printing, and—very importantly—the behind-the-scenes conceptual thinking that goes into coming up with layouts, illustrations, and photographs that are visually and thematically attractive and engaging.

The 95 topics covered in this book are offered at a rate of exactly one subject per spread, and each topic is presented through more or less equal parts text and imagery. Nearly all the book's content is delivered through a visual vocabulary of Helvetica and dingbats (typographic families of symbols, imagery, and ornaments). Which brings up the obvious questions, *Exactly why is this book's subject matter presented using Helvetica and dingbats, and why are there 95 topics?*

First off, there are 95 topics simply because the rounder and more complete-feeling number of 100 wouldn't fit into the 240-page format of this book. That's all. (But that doesn't mean anything important was left out: As any writer could tell you, there are always ways of combining two or more subjects under the umbrella of a single larger topic.)

6

As far as the Helvetica and dingbats go, to explain their role in *Visual Design* is also to explain and emphasize one of this book's primary goals—that of being able to offer artists a ton of highly applicable information without overly influencing the ways in which that information might be put to use. So here goes: Helvetica was chosen as the font for this book's text—and for nearly all of the words used within its images—simply because Helvetica is one of those very rare fonts that cannot only deliver a wide range of thematic conveyances (think, for instance of the elegant look of a headline set in the thinnest possible weight of Helvetica versus the commanding boldness of a block of text set in Helvetica Black), but it can also act as an almost invisible thematic component for a layout or illustration whose other visual elements are meant to set the piece's mood. Know many other fonts that can claim this remarkable set of qualities in quite the same way? I don't.

Dingbats and ornaments are used as the main visual element for the vast majority of this book's images for similar reasons: Because dingbats—like Helvetica—tend to convey themselves without a great deal of self-aggrandizing fanfare, and therefore are capable of adapting to a wide range of styles and moods within the layouts and illustrations they inhabit.

That's why Helvetica and dingbats have been used to deliver this book's informational, conceptual, and visual content: In order to spark inspiration and ideas in the minds of viewers without calling any more attention to these visual components than necessary. Also, on the level of visual entertainment alone, I hope you enjoy seeing the ways in which characters of the Helvetica font family—and those from a variety of dingbat families—have been used to uniquely illustrate this book's subject matter.

Just a couple more notes about the content of *Visual Design*—one regarding the depth of coverage seen throughout the book, and the other about the software mentioned in its pages.

Some of this book's topics—like those dealing with broad aspects of composition and aesthetics (primarily covered in Chapters 1 through 6)—are presented in considerable depth and completeness. Other subjects—such as typography and color—will themselves be topics that fill entire books in future additions to the Creative Core series. Naturally, the attention these large-scale topics receive in this book is abridged in comparison to how they will be covered in volumes of their own, but readers should still find that these subjects have been dealt with in a solid, practical, instructive, and enlightening way within the chapters of *Visual Design*.

This book was created using the same trio of software programs that most designers, illustrators, and photographers use to create their own works of design and art: Adobe InDesign, Illustrator, and Photoshop. In most cases, when these programs are mentioned, it is without a great deal of specifics in terms of what buttons to push or what pull-down menus to activate. Why is this? It's simply because software changes quickly and often, and the hope is that the information in this book will be of a much more long-lasting nature than is generally found when it comes to computers and software. So, if you come across a tip in this book about using such-and-such program to help you perform such-and-such task, I hope—if necessary—you'll be willing to open that program's Help menu to find out how the current version of the software handles these matters. (To me, this is really the best way of learning new things about software anyway—since it almost always leads to discoveries of other menu items and tools that may come in handy for other tasks.)

Finally, thank you for taking a look at *Visual Design*. This is my fourteenth book on subjects dealing with design, creativity, and digital photography, and its content is near and dear to the creative centers of my brain and being. I hope you enjoy it and find it helpful in creating your own personal and professional expressions of visual art.

Jim Krause
JIMKRAUSEDESIGN.COM

CREATIVE CORE
BOOK01

Visual Design is the first book in the New Riders Creative Core series.

The second book in the series (available now) is *Color for Designers*—a book that significantly expands upon the color-related information offered in Chapters 7 and 8 of this book.

A third title, *Lessons in Typography,* is due on the shelves in 2015. Keep your eyes open for more offerings from this series in the future.

CHAPTER 1

Setting the Stage

1 PROPORTIONAL CONSIDERATIONS

Layouts are like stages. The images, headlines, text, graphics, logos, patterns, and colors that fill layouts are like characters on a stage. It's up to the designer to decide where each character is to be placed, which ones are to play leading roles, and which are to provide support.

12 But first things first. Do you know the shape and dimensions of the stage you'll be filling? Are your layout's dimensions preordained, as in the case of an advertisement, a brochure, or a Web page of a specified size? If so, then you can get directly to the work of coming up with ideas for filling the area inside your layout's borders with aesthetically effective and conceptually compelling content.

Do you have a say in your layout's proportions and shape, as with a custom-designed brochure, poster, or handout? If so, brainstorm possibilities that are both commonplace and out of the ordinary.

Consider proportions when working on logos as well. Think about the general (or exact) proportions of the space you'd like to fill with your design: square, rectangular, triangular, circular, elliptical, freeform. Ask yourself, *Is this a design that should fit within relatively standard proportions, or would it look—and function— better if it were notably wider, taller, or more irregularly shaped than most logos?*

Explore proportional considerations—as well as layout, content, and stylistic ideas—through thumbnail sketches. Thumbnail sketches (also known simply as thumbnails) are like visual shorthand: quickly drawn, usually small, and rarely neat. You can employ sketches like these as a flexible and free-flowing way of trying out and recording ideas for any kind of design or illustration project. Don't be stingy when working with thumbnail sketches: Designers and illustrators often need to produce at least a large page or two of thumbnails before the better ideas really start percolating.

2 DEFINING BOUNDARIES

The edges of a piece of paper often act as the de facto boundaries of layouts and images.

Boundaries involving linework or areas of color are regularly added to logos, photographs, illustrations, and advertisements to add notes of style, to help their compositional elements hold together as unified entities, and/or to set them apart from other visuals on a page.

14

Employing a simple 1-point line can define the boundary of a composition, as can lines of other weights. Dotted, doubled, tripled, ornate, or hand-drawn lines can function nicely as bordering elements. Using a band of color, a repetitive pattern, or a series of decorative elements can define a layout's perimeter. Establish borders by darkening, lightening, vignetting, or roughing up the edges of a layout or an illustration.

Use a colored or image-filled backdrop panel to define the outer edges of a composition.

Boundaries can be precisely defined and rigorously enforced. Boundaries can also be indistinct and porous (note how the letter e has been allowed to escape its bounding box in the illustration at right).

Consider allowing bordering elements to contribute to a piece's stylistic and thematic conveyances whenever enclosing a layout or an image with a visual boundary. Linework that includes subtle swirls or ornaments at its corners, for instance, might be used to boost the connotations of elegance on a jeweler's business card, and a scruffy hand-sketched line around likewise rough-looking typography might be just what's needed to complete a logo for a contemporary fashion designer.

3 MARGINS

How much space should there be between your layout's elements (headline, text, image, logo, etc.) and its boundaries? There is no one-size-fits-all answer to this question, but it is a question that needs to be considered with every design you create.

If you want to give your layout a clean, light, and airy look, you might want to establish larger-than-normal margins between the composition's interior elements and its borders. If your layout is meant to project inferences of bustle or chaos, then—instead of leaving a clean margin of white space around your layout's interior components—consider crowding the edges of the composition with images, decorations, or typography.

In addition to aesthetic considerations, keep practicality in mind when deciding on margins. For example, if you're creating a layout for a small-space advertisement that is to appear on a page crowded with other ads, work hard to establish enough of a margin between your ad's content and its borders to keep it from inadvertently blending in with neighboring visuals. (This can be a real challenge at times, and it may mean working closely with the ad's copywriter to limit the amount of text your small-space composition needs to contain).

Margins can all be the same width or they can be varied. Which approach suits your project best? Consider the merits of both dynamic and static spacing (covered on pages 30 and 32) when deciding this question.

If you're designing the interior pages of a thick book or a magazine, consider granting extra space to its inside margins since a bit of this page-territory may be consumed by the piece's gutters.*

*See the glossary beginning on page 226 for definitions of unfamiliar terms.

top margin: .75 inches

outside margin: 1 inch

inside margin: 1 inch

S	o	m	e	*	*	*	*	*	*
*	*	*	s	p	a	c	e	s	*
*	w	e	r	e	*	*	*	*	*
*	*	*	*	*	m	e	a	n	t
t	o	*	b	e	*	*	*	*	*
*	*	f	i	l	l	e	d	*	*
*	a	n	d	*	s	o	m	e	*
a	r	e	*	b	e	t	t	e	r
*	l	e	f	t	*	*	*	*	*
*	*	*	*	e	m	p	t	y	*

bottom margin: .70 inches

4 COLUMNS

Columns—as you probably know—are the invisible vertical containers commonly used to hold a layout's text, images, and decorations in an orderly manner.

Columns can be friends to both designers and viewers. For designers, being able to build a layout around columns means a measure of aesthetic and stylistic freedom when choosing how many columns to employ, how much space to leave between the columns, and whether to obey or defy a layout's columnar guides as they're filled with text and images.

Viewers appreciate the sense of order that columns can bring to a composition by letting them know—right up front—that their eyes and brains will not be confounded as they delve into a layout's content. Columns do this by presenting viewers with a tidy structure that promises to deliver information in a sensible and easily followed manner.

Readers also benefit from text that is set into columns that are neither too wide nor too narrow: Text that is set in overly wide columns can cause readers to lose their place as their eyes travel from one line to the next; text that is set in columns that are too narrow may result in annoyingly frequent hyphenations and line breaks.

Whenever using columns in a layout, pay attention not only to their number and width, but also to the spaces between them. Alleys between columns should be wide enough to keep the eye from accidentally flowing into neighboring columns when reading lines of text— but not so wide that the columns have a loose-jointed feeling of disconnection.

Experiment with different column settings when preparing a layout document. Determine how few— and how many—columns your layout could feasibly hold and then ask yourself, *Which solution between these extremes feels best in terms of both practicality and style?*

4 column layout

Headline

Lorem ipsum dolor sit amet, consectetur adipisicing elit, sed do eiusmod tempor incididunt ut labore et dolore magna aliqua. Ut enim ad minim veniam, quis nostrud exercitation ullamco laboris nisi ut aliquip ex ea commodo consequat. Duis aute irure dolor in reprehenderit in voluptate velit esse cillum dolore eu fugiat nulla pariatur. Excepteur sint occaecat cupidatat non proident, sunt in culpa qui officia deserunt mollit anim id est laborum. Lorem ipsum dolor sit amet, consectetur adipisicing elit, sed do eiusmod tempor incididunt ut labore et dolore magna aliqua. Ut enim ad minim veniam, quis nostrud exercitation ullamco laboris nisi ut aliquip ex ea commodo consequat. Duis aute irure

dolor in reprehenderit in voluptate velit esse cillum dolore eu fugiat nulla pariatur. Excepteur sint occaecat cupidatat non proident, sunt in culpa qui officia deserunt mollit anim id est laborum. Lorem ipsum dolor sit amet,

IMAGE

consectetur adipisicing elit, sed do eiusmod tempor incididunt ut labore et dolore magna aliqua. Ut enim ad minim veniam, quis nostrud exercitation ullamco laboris nisi ut aliquip ex ea commodo consequat. Duis aute irure dolor in reprehenderit in voluptate velit esse cillum

dolore eu fugiat nulla pariatur. Excepteur sint occaecat cupidatat non proident, sunt in culpa qui officia deserunt mollit anim id est laborum. Lorem ipsum dolor sit amet, consectetur adipisicing elit, sed do eiusmod tempor

IMAGE

incididunt ut labore et dolore magna aliqua. Ut enim ad minim veniam, quis nostrud exercitation ullamco laboris nisi ut aliquip ex ea commodo consequat. Duis aute irure dolor in reprehenderit in voluptate velit esse cillum dolore eu fugiat nulla pariatur. Excepteur sint occaecat

cupidatat non proident, sunt in culpa qui officia deserunt mollit anim id est laborum. Lorem ipsum dolor sit amet, consectetur adipisicing elit, sed do eiusmod tempor incididunt ut labore et dolore magna aliqua. Ut enim ad minim veniam, quis nostrud

1 column layout

Headline

Lorem ipsum dolor sit amet, consectetur adipisicing elit, sed do eiusmod tempor incididunt ut labore et dolore magna aliqua. Ut enim ad minim veniam, quis nostrud exercitation ullamco laboris nisi ut aliquip ex ea commodo consequat. Duis aute irure dolor in reprehenderit in voluptate velit esse cillum dolore eu fugiat nulla pariatur. Excepteur sint occaecat cupidatat non proident, sunt in culpa qui officia deserunt mollit anim id est laborum. Lorem ipsum dolor sit amet, consectetur adipisicing elit, sed do eiusmod tempor incididunt ut labore et dolore magna aliqua. Ut enim ad minim veniam, quis nostrud exercitation ullamco laboris

2 column layout

Headline

IMAGE

Lorem ipsum dolor sit amet, consectetur adipisicing elit, sed do eiusmod tempor incididunt ut labore et dolore magna aliqua. Ut enim ad minim veniam, quis nostrud exercitation ullamco laboris nisi ut aliquip ex ea commodo consequat. Duis aute irure dolor in reprehenderit in voluptate velit esse cillum dolore eu fugiat nulla pariatur. Excepteur sint occaecat cupidatat non proident, sunt in culpa qui officia deserunt mollit anim id est laborum. Lorem ipsum dolor sit amet, consectetur adipisicing elit, sed do eiusmod tempor incididunt ut labore et dolore magna aliqua. Ut enim ad minim veniam, quis nostrud exercitation ullamco laboris nisi ut aliquip ex ea commodo

dolor in reprehenderit in voluptate velit esse cillum dolore eu fugiat nulla pariatur. Excepteur sint occaecat cupidatat non proident, sunt in culpa qui officia deserunt mollit anim id est laborum. Lorem ipsum dolor sit amet, consectetur adipisicing elit, sed do eiusmod tempor incididunt ut labore et dolore magna aliqua. Ut enim ad minim veniam, quis nostrud exercitation ullamco laboris nisi ut aliquip ex ea commodo consequat. Duis aute irure dolor in reprehenderit in voluptate velit esse cillum dolore eu fugiat nulla pariatur. Excepteur sint occaecat cupidatat non proident, sunt in culpa qui officia deserunt mollit anim id est laborum. Lorem ipsum dolor sit amet.

5 column two-page layout

Headline

Lorem ipsum dolor sit amet, consectetur adipisicing elit, sed do eiusmod tempor incididunt ut labore et dolore magna aliqua. Ut enim ad minim veniam, quis nostrud exercitation ullamco laboris nisi ut aliquip ex ea commodo consequat. Duis aute irure dolor in reprehenderit in voluptate velit esse cillum dolore eu fugiat nulla pariatur. Excepteur sint occaecat cupidatat non proident, sunt in culpa qui officia deserunt mollit anim id est laborum. Lorem ipsum dolor sit amet, consectetur adipisicing elit, sed do eiusmod tempor incididunt ut labore et dolore magna aliqua. Ut enim ad minim veniam, quis nostrud exercitation ullamco laboris nisi ut aliquip ex ea commodo consequat. Duis aute irure dolor

in reprehenderit in voluptate velit esse cillum dolore eu fugiat nulla pariatur. Excepteur sint occaecat cupidatat non proident, sunt in culpa qui officia deserunt mollit anim id est laborum. Lorem ipsum dolor sit amet.

IMAGE

consectetur adipisicing elit, sed do eiusmod tempor incididunt ut labore et dolore magna aliqua. Ut enim ad minim veniam, quis nostrud exercitation ullamco laboris nisi ut aliquip ex ea commodo consequat. Duis aute irure dolor in reprehenderit in voluptate velit esse cillum dolore eu fugiat nulla pariatur. Excepteur sint occaecat cupidatat

non proident, sunt in culpa qui officia deserunt mollit anim id est laborum. Lorem ipsum dolor sit amet, consectetur adipisicing elit, sed do eiusmod tempor incididunt ut labore et dolore magna aliqua. Ut enim ad minim veniam, quis nostrud exercitation ullamco laboris nisi ut aliquip ex ea commodo consequat. Duis aute irure dolor in reprehenderit in voluptate velit esse cillum dolore eu fugiat nulla pariatur. Excepteur sint occaecat cupidatat non proident, sunt

ullamco laboris nisi ut aliquip ex ea commodo consequat. Duis aute irure dolor in reprehenderit in voluptate velit esse cillum dolore eu fugiat nulla pariatur. Excepteur sint occaecat cupidatat non proident, sunt in culpa qui officia deserunt mollit anim id est laborum. Lorem ipsum dolor sit amet, consectetur adipisicing elit, sed do eiusmod tempor incididunt ut labore et dolore magna aliqua. Ut enim ad minim veniam, quis nostrud exercitation ullamco laboris nisi ut aliquip ex ea commodo consequat.

id est laborum. Lorem ipsum dolor sit amet, consectetur adipisicing elit, sed do eiusmod tempor incididunt ut labore et dolore magna aliqua. Ut enim ad minim veniam, quis nostrud exercitation ullamco laboris nisi ut aliquip ex ea commodo consequat. Duis aute irure dolor in reprehenderit in voluptate velit esse cillum dolore eu fugiat nulla pariatur. Excepteur sint occaecat cupidatat non proident, sunt in culpa qui officia deserunt mollit anim

consectetur adipisicing elit, sed do eiusmod tempor incididunt ut labore et dolore magna aliqua. Ut enim ad minim veniam, quis nostrud exercitation ullamco laboris nisi ut aliquip ex ea commodo consequat. Duis aute irure dolor in reprehenderit in voluptate velit esse cillum dolore eu fugiat nulla pariatur. Excepteur sint occaecat cupidatat non proident, sunt in culpa qui officia deserunt mollit anim id est laborum. Lorem ipsum dolor sit amet, consectetur adipisicing elit, sed do eiusmod tempor incididunt ut labore et dolore magna aliqua. Ut enim ad minim veniam, quis nostrud exercitation ullamco laboris nisi ut aliquip ex ea commodo consequat. Duis aute irure dolor in reprehenderit in

voluptate velit esse cillum dolore eu fugiat nulla pariatur. Excepteur sint occaecat cupidatat non proident, sunt in culpa qui officia deserunt mollit anim id est laborum. Lorem ipsum dolor sit amet, consectetur adipisicing elit, sed do eiusmod tempor incididunt ut labore et dolore magna aliqua. Ut enim ad minim veniam, quis nostrud exercitation ullamco laboris nisi ut aliquip ex ea commodo consequat. Duis aute irure dolor in reprehenderit in voluptate velit esse cillum dolore eu fugiat nulla pariatur. Excepteur non proident, sunt in culpa qui officia deserunt mollit anim

IMAGE

labore et dolore magna aliqua. Ut enim ad minim veniam, quis nostrud exercitation ullamco laboris nisi ut aliquip ex ea commodo consequat. Duis aute irure dolor in reprehenderit in voluptate velit esse cillum dolore eu fugiat nulla pariatur. Excepteur non proident, sunt in culpa qui officia deserunt mollit anim

id est laborum. Lorem ipsum dolor sit amet, consectetur adipisicing elit, sed do eiusmod tempor incididunt ut labore et dolore magna aliqua. Ut enim ad minim veniam, quis nostrud exercitation ullamco laboris nisi ut aliquip ex ea commodo consequat. Duis aute irure dolor in reprehenderit in voluptate velit esse cillum dolore eu fugiat nulla pariatur. Excepteur non proident, sunt in culpa qui officia deserunt mollit anim

sint occaecat cupidatat non proident, sunt in culpa qui officia deserunt mollit anim id est laborum. Lorem ipsum dolor sit amet, consectetur adipisicing elit, sed do eiusmod tempor incididunt ut labore et dolore magna aliqua. Ut enim ad minim veniam, quis nostrud exercitation ullamco laboris nisi ut aliquip ex ea commodo consequat.

5 GRIDS

A grid is a set of reference guidelines that as a designer you can set up in order to generate cues for the placement of a layout's components. Grids not only establish where a layout's text-filled vertical columns will reside, they also help determine the upper and lower horizontal boundaries of these columns. A layout's grid can also regulate the horizontal positioning of compositional elements like headings, images, and logos.

You typically set up grids by using a combination of computer-generated column guides and user-placed horizontal and vertical guides from within programs like Adobe InDesign, Illustrator, and Photoshop. You can use these on-screen guides to direct you as you place content into your layouts, and you can toggle the guides on and off as you work.

You can use grids to set up the look of a one-time document like a poster or an advertisement. You can also employ grids to establish a sense of consistency across multiple pages or multiple documents—as in the case of the pages of an annual report or a series of promotional brochures.

Depending on the look you're after, you can set down a grid as a kind of visual law that demands that all elements of a layout align and adhere to its structure.

You can also place a grid as a general set of guidelines that can be defied here and there in the interests of aesthetic variety and stylistic flair.

You can devise grids in an infinite number of ways. Since this is such a big topic it wouldn't be a bad idea to pick up at least a couple books on grids and to study them well. Once you understand how grids work you should have little trouble coming up with grids of your own for projects that call for them. Also, the better acquainted you become with grids and their uses, the better you will become at sensing when and how they should be ignored (more on this on the next spread).

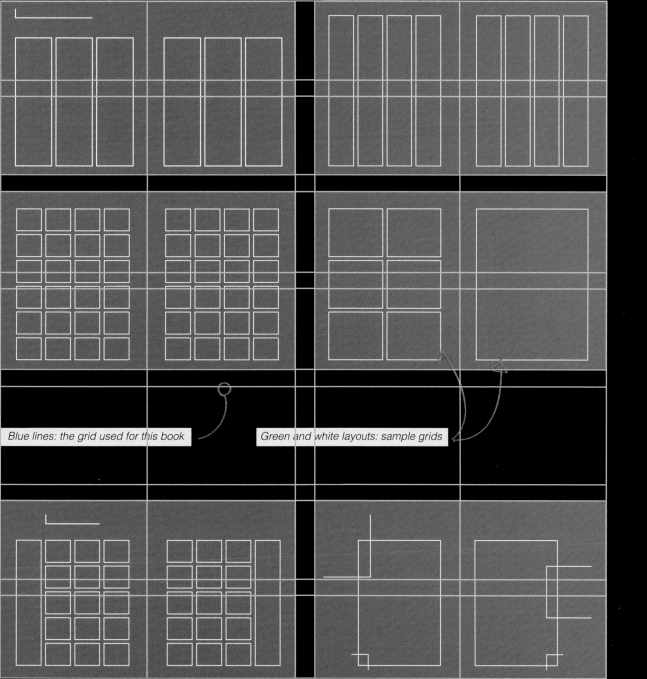

Blue lines: the grid used for this book *Green and white layouts: sample grids*

6 DEFYING THE GRID

Grids are the law only when *you* decide they are the law. And when you decide your layout's grid is simply offering polite suggestions as to where things are placed and how they align, well, then that's how it is.

Unless, of course, outside factors intervene. Some companies, for instance, have graphics standards manuals that dictate the degree to which their official corporate grid is to be obeyed.

Most of the time, however, the grids you'll be working with are grids that you'll have created for the purposes of a specific project, and it's you who will be deciding under what conditions—if any—they can be ignored and to what degree.

Most designers who regularly use grids understand very well that their eye and their art-sense are the final arbitrators when it comes to deciding whether or not certain compositional elements should be precisely aligned with an underlying grid, sort of aligned, or not at all aligned. When working on something like an annual report for an investment firm, for example, a designer's instincts might advise them to stick closely to a grid's structure in order to convey the no-nonsense demeanor of the company. On the other hand, if a designer is working on an illustrated e-book about fun and festive backyard garden projects, then visual elements might be allowed to snub the grid's structure often and blatantly in the interests of boosting themes of a more playful nature.

You might have noticed that the grid used for this spread's illustration is the same that was used on the previous spread. Same grid, two very different outcomes; same grid, two different levels of adherence. In fact, each spread in this book was built using the same grid as a guideline: Some spreads adhere closely to its structure while others… not so much.

7 BACKDROPS

Many layouts and illustrations are presented directly against a white piece of paper or the white of a digital display. And why not? White can provide the perfect setting for an ad, an article, a Web page, a poster, a logo, or an illustration. And while there is nothing inherently wrong with white backdrops, they are not always the most effective solution.

You can employ backgrounds of subtle color when you want to soften the visual impact that occurs when dark foreground elements are set against a stark white backdrop—and also when a light touch of thematic interest is being sought. You might use a backdrop of light ivory, for instance, to add notes of elegance, era, or age to a layout that uses typefaces and visuals that concur with themes such as these.

You can also use deeper colors to fill the background of a layout. The colors could be bright, dark, or muted. Naturally, take care when working with brighter and/

or darker backdrop colors to make sure that a layout's text remains legible. This may mean presenting the text in either white or a light color.

Clear differences in value (defined on page 122) are key to ensuring that text and other foreground elements of a work of design or art stand out properly against their backdrop. This holds true whether the backdrop is a color, a texture, a pattern, or an image.

You can also make backdrops something other than a solid expanse of color. You can use visual textures (see page 102) effectively as background material, just as you can patterns, decorations, and images.

Think about it the next time you're beginning work on a layout, an illustration, or a logo and ask yourself: *Would a backdrop for this piece help set the stage for its aesthetic and thematic goals?*

24

8 BACKDROP PANELS

Use backdrop panels to highlight chosen elements of a layout, to help bring order to a complex design, or to add notes of visual interest to a composition.

Use backdrop panels to highlight logos, quotes, text, captions, headlines, and illustrations.

Try using panels of white, black, or color to protect the readability of text that's placed over a visually active backdrop.

Not all backdrop panels are equal: they can be extremely subtle or overtly attention-grabbing.

Backdrop panels can be geometrically or irregularly shaped…

they can be filled with a solid color or they can contain many hues…

they can be filled with visual texture, decorations, a pattern, or an image…

they can be straight or tilted…

they can be bordered with or without linework…

their edges can be sharp or blurred…

and they can be finalized with drop shadows, transparency effects, and dimensional treatments.

Backdrop panels are a worthwhile option to keep in mind when working on layouts. And while the use of backdrop panels is rarely a must, they can sometimes provide just the organizational, thematic, or aesthetic touch a layout needs in order to improve its look and its ability to communicate a message.

26

28 | CHAPTER 2

Filling
Spaces

9 DYNAMIC SPACING

A layout's headline, text, illustrations, and decor can each catch, hold, and excite a viewer's interest.

And—surprisingly enough—the spaces *between* and *around* the elements of a composition can also have an effect on its visual impact. A significant effect, in fact.

The principle of dynamic spacing is very important to recognize and heed, and it goes something like this: *Variety in the spaces seen among and around compositional elements increases inferences of activity and excitement, and a lack of variety among spaces promotes conveyances of a subdued, matter-of-fact—and possibly boring—nature.*

Take a look at the images and captions on the facing page. These provide a boiled-down demonstration of dynamic spacing at work, and their lessons can be broadly applied to virtually any work of design or art—

whether you are determining spaces between a logo's elements, between a layout's content and its borders, between an ad's headline and its text, or between the various components of an illustration.

Stretch the principle of dynamic spacing to connect with a similar principle: *Greater differences in the sizes and the proportions of a composition's elements lead to stronger expressions of dynamism and action, while lesser differences in size and proportion do the opposite.*

You can see examples that confirm these related concepts throughout this book, as well as throughout the whole wide worlds of design and art. Take note of the way great designers, artists, and photographers employ both differences and similarities in the application of spacing, sizing, and proportioning in their work, and also pay attention to the effects that are produced through these choices.

This composition's central element has been placed dead-center: The distances above and below the element are the same, as are the distances to either side of the element. This is static placement, and conveyances of visual charisma are limited when compositional components are positioned in this way. (More on static placement on the next spread.)

static placement

Visual conveyances of energy and dynamism are increased when the measurements above, below, and to either side of compositional elements are varied. Varied distances between individual components of a composition also increase inferences of vitality.

dynamic placement

Complexity and variety between a composition's spaces, its placement of elements, and the sizes of its components maximizes conveyances of compositional vivacity.

dynamic divisions of space
& _dynamic_ placement of elements
& _dynamic_ differences in sizes

10 STATIC PLACEMENT

Dynamic spacing is a great way of increasing the visual charisma of a composition.

But what about a layout that is supposed to come across with an air of reserve and formality? Or an image whose content is intended to convey inferences of inertia and restraint? And what about an advertisement whose humorous message might best be presented through a subversively straight-laced delivery? Each of these creations could benefit from a compositional structure that is more static than dynamic.

Static, of course, is the opposite of dynamic. It makes good sense, then, that whatever you might do to convey visual charisma, you could probably do the opposite in order to deliver themes of a more dispassionate nature.

For instance, instead of featuring spirited discrepancies in the spaces between—and the sizes of—your composition's elements, employ instead

measurements and sizes that are similar. Cut down, in other words, on visual differences when striving for aesthetic expressions of inaction or moderation.

Symmetry can also come into play when seeking a look of visual restraint. For example, placing your subject dead center in an illustrated or a photographic scene will naturally tend to lower the composition's conveyances of energy due to the similar distances on either side of the subject. The same goes for when the horizon of a scene is placed near dead center of a composition's vertical space, and thereby establishes a look of symmetry between its upper and lower regions (the next spread contains more thoughts about the effects of symmetry versus those of asymmetry).

In most cases, it's important to maintain a sense of visual hierarchy (page 50) when creating layouts or illustrations. However, when you're seeking connotations of overt restraint, inferences of compositional hierarchy might be kept at a bare minimum or avoided completely.

11 SYMMETRY VS. ASYMMETRY

You'll often see these two words used together in this book: be and decisive. You'll see them in just that order and in sentence form: Be decisive. Sometimes the sentence will even be in italic and will be followed by an exclamation mark: *Be decisive!*

Why these two words? Why so often, and why with such emphatic emphasis? It's because of the crucial importance of avoiding appearances of indecision when creating compositions. Hints of indecision leave the viewer wondering, *Did the designer really know what they were doing when they created this piece? Did they have a clear purpose in mind? Were they paying attention to their work?*

These are the last things a viewer wants to think about when looking at a layout or an illustration: Most viewers would much rather be intrigued, educated, entertained, humored, or pleased (and in some cases, all of the above) when looking at a work of design or art than to be put in the position of wondering about the skills and the intentions of the person who created it.

All of which brings us to a piece of advice concerning symmetry and asymmetry: *Be decisive!*

If the elements of your layout are supposed to be either symmetrically or asymmetrically arranged, then don't allow them to hover in the gray area between symmetry and asymmetry: Push the arrangement clearly into one realm or the other.

A note about symmetry: Symmetry need not be mathematically precise to come across as symmetry. Neither the top portion of the illustration on this spread nor the photograph on the previous page are literally symmetrical, but they both come across as such. Let your art-sense guide you when deciding just how close to the dictionary definition of symmetry you need to come to convey its aesthetic notion of symmetry.

symmetry

asymmetry

12 ALIGNING, AND NOT

Generally speaking, visual alignment lends notes of order to a design while non-alignment delivers connotations of a more casual nature.

See the bold G at the beginning of this text? Notice how its top aligns with the horizontal arms of the large star on the opposite page? Also, notice how the tip of the airplane's right wing aligns with the far-right point of the star? Neither of these alignments are accidental: both have been included as part of this spread's structure to contribute to its subtle inferences of aesthetic forethought and sensibility—inferences that are meant to contrast notably with the visual frivolity conveyed elsewhere. (Impertinent themes like frivolity are likely to gain a boost when presented in contrast with at least a touch of compositional seriousness.)

And just how has this illustration been infused with conveyances of frivolity? Partly through its nonsensical presentation of subject matter, for sure. And also by

intentionally avoiding an over-abundance of perfectly aligned compositional elements among its components. (Study this spread for a few moments and you'll see that there are few instances of careful alignment other than the two previously mentioned.)

Adjustments to a composition's conveyances—ranging from seriousness to casualness to outright silliness—can be affected by the degree to which its components either align or don't. Keep this in mind when fine tuning the placement of any composition's elements.

And by all means, keep a sharp eye on your work and make sure that all the relationships between your visual components come across as either definitely aligned or definitely non-aligned: It tends to look as though a mistake has been made when elements are almost—but not quite—lined up. (Be decisive, in other words, when choosing whether or not to align.)

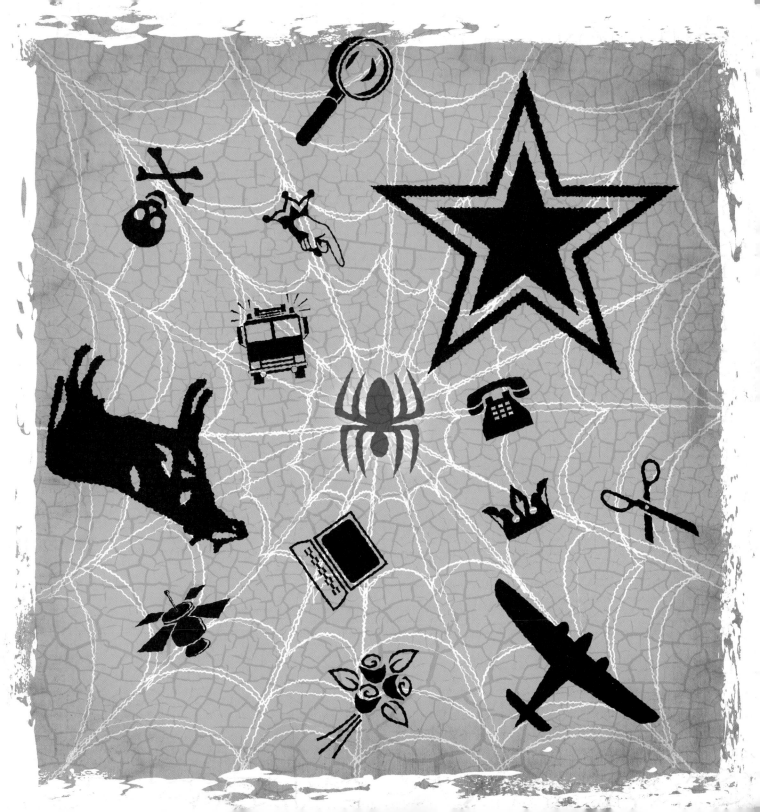

13 THE GOLDEN RATIO

Artists and architects long ago discovered that one particular ratio between measurements seems especially pleasing to the eye. This ratio has become known as the *golden ratio* and many scientists, anthropologists, and artists believe this ratio—because nature itself has applied it so plentifully to things as diverse as the structure of a leaf's veins, the divisions of a snowflake's arms, and the coil of a nautilus's shell—has come to be accepted as an embodiment of functional and visual perfection.

The golden ratio is represented by the Greek letter phi (Φ). Phi, like the more commonly known pi (π), is an irrational number (a number followed by infinite non-repeating decimal places). The first ten digits of phi are 1.6180339887, but you can safely round this off to 1.62 to compute reasonably accurate golden ratios. To find a golden ratio between measurements, simply start with the smaller measurement of the pair and multiply it by 1.62 to produce the larger measurement. For example, 6" x 1.62 (phi) = 9.72" (and therefore the measurements of 6" and 9.72" are a golden ratio).

Finding golden ratios does not need to happen every time you work on a design project, but it is a reliable, versatile, and time-tested way of coming up with good-looking divisions of space within the grids you create for layouts, to determine attractive size relationships between compositional elements, and to guide you when developing eye-pleasing patterns out of geometric or freeform shapes.

Follow the instructions on the opposite page if you would personally like to experience the golden ratio at work. You could easily do this project on your computer using a program like Illustrator, or with a piece of paper, a pencil, a ruler, and a calculator.

1 Choose a measurement for the short side of your rectangle.

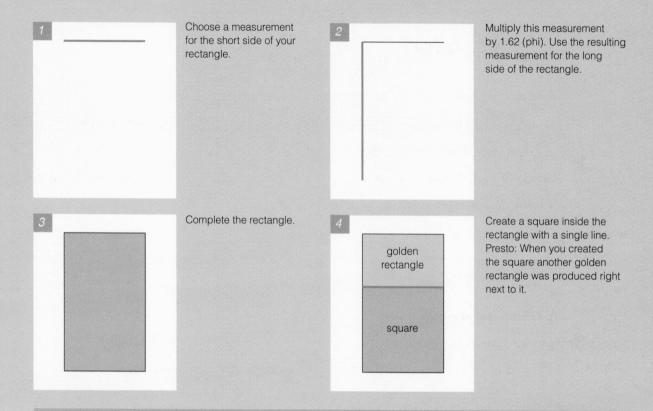

2 Multiply this measurement by 1.62 (phi). Use the resulting measurement for the long side of the rectangle.

3 Complete the rectangle.

4 Create a square inside the rectangle with a single line. Presto: When you created the square another golden rectangle was produced right next to it.

golden rectangle

square

Golden Rectangles: Step by Step

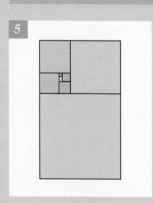

5 Continue dividing your golden rectangles into further square/rectangle combos as many times as you like.

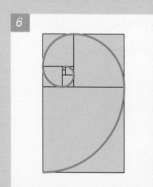

6 Bonus step: add a perfect semicircle inside each square and then connect the semicircles to create a beautiful nautilus-like swirl.

14 OVER AND UNDER

As you fill your composition's space, keep in mind that the work of a designer not only includes looking for ways of making things fit together, it can also include finding ways of stacking, overlapping, or weaving visual elements (figuratively speaking, of course, in the case of the two-dimensional media being covered in this book.)

Layouts, logos, and illustrations can all include elements that appear to jump over or dive under other compositional components. Programs like Photoshop, Illustrator, and InDesign make illusions like these easy to deliver through drop shadows, dimensional effects, and translucency treatments.

With 3D rendering software, too, you can produce dimensional illustrations that feature all kinds of over, under, twisting, and spiraling visual components. Programs of this kind may take a while to fully learn, but the good news is that you need only a basic understanding of 3D software in order to create eye-popping images.

And, of course, illusions such as these can also be produced in the old-school way using pencil, ink, and paint (or the digital equivalents of these media)—as demonstrated to the peak of perfection by the artist M.C. Escher.

Be advised that any and all illusory effects used in design—just like the card tricks performed by real-life magicians—become old news when they are seen too often or in too much the same way. Also be aware that all special effects—just like all other forms of visual entertainment—are subject to the whims of fad and fashion: The specific styles of drop shadows, dimensional effects, and translucency treatments that are popular today are certain to be replaced by different incarnations of these same effects in a not-too-distant tomorrow.

15 ALTERNATIVE ORIENTATIONS

The type you are now reading is right-side-up, it flows horizontally from left to right, and its lines progress from top to bottom. This is considered normal in English-speaking cultures and it is how English words are usually presented.

There's absolutely nothing wrong with filling a layout with typography and images that are configured in this way: right-side-up and on the straight-and-level. In fact, the vast majority of the world's works of design are filled with compositional elements that are oriented in just this way.

Still, a designer should always be open to at least considering out-of-the-ordinary options in this regard— options like vertical type, backwards-reading words, upside-down photos, and slanting graphics.

Presentations along these lines can be used to call attention to a layout or an illustration, to deliver a conceptual meaning, or to entertain the eye.

As long as a piece's message isn't obliterated by text that loses its legibility or visuals that become nonsensical, then alternatives to commonplace orientations should be worth at least a moment's contemplation when developing a layout or an illustration. If you decide to pursue an idea that features upside down, backwards, or slanted visual elements, then take advantage of your computer's ability to make this kind of creative exploration exceedingly easy and flexible.

42

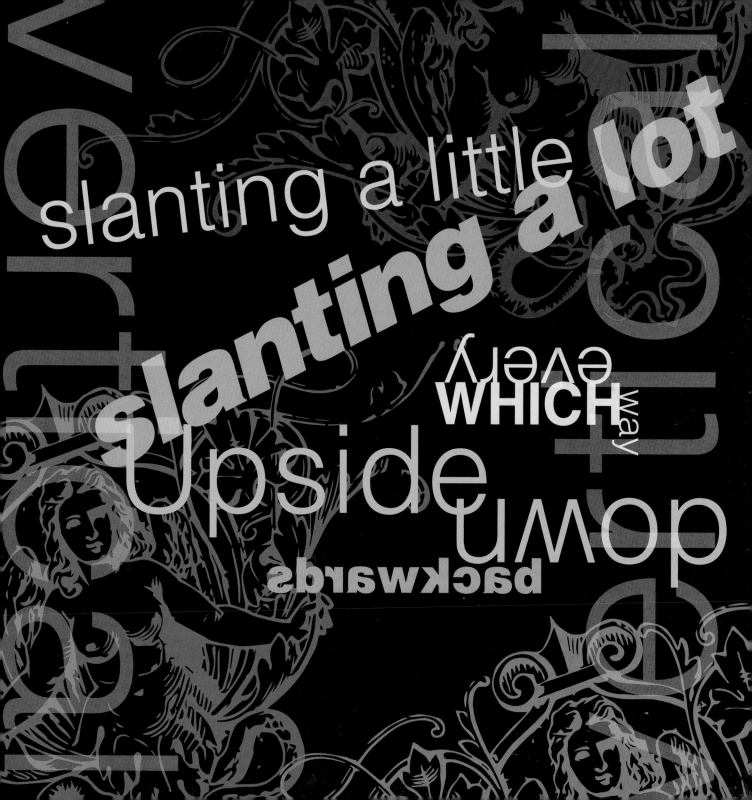

slanting a little

slanting a lot

slanting a lot

Upside

down

WHICH

every

way

backwards

16 MINIMALISM

Not all works of art or design can benefit from a minimalistic approach.

But it sure is nice when it happens—when a less-is-more approach can send just the right message.

Seize the opportunity the next time you're working on a project that can say much through little.

17 INTENTIONAL COMPLEXITY

There are times when more *is more* and when less is simply a bore: Some messages can *only* be delivered through the visual verbosity of complexity and crowding.

Keep in mind that complexity and crowding need not equate to pandemonium. Compositions that are heavily populated can be either orderly or chaotic, informative or confused, humorous or irritating, entertaining or frustrating.

Which thematic inferences are you aiming for? How can you get there? Consider the effects of spacing and symmetry (pages 30 to 35), visual hierarchy (page 50), framing (page 54), pointing elements (page 60), and color schemes (Chapter 8, Color and Conveyance) when aiming to generate specific conveyances through visually complex compositions.

Thumbnail sketches are a great place to start when developing complex visuals. Begin by coming up with basic sketches of what your composition might include and how its content might be arranged. And once you have a sketch or two that are more or less aiming in the right direction, start using layers of tracing paper to further advance the look of your piece. (Tracing paper—in case you've never used it for developing layouts and illustrations—can be an incredible time-saving and quality-enhancing medium.) Once you're reasonably happy with your penciled composition, you can then scan and import it into the computer for use as a guide as you finalize the image.

When working on a composition that includes much in the way of visual material, the question always arises, *How much is too much?* One excellent way of affirming an answer to this question is by going too far. That's right: Add too much, make things crazier than they should be, and then simplify the composition to the point where it seems to have just the right amount of complexity.

48 | CHAPTER 3

Directing the Eye

18 VISUAL HIERARCHY

Visual hierarchy is the pecking-order of a composition's elements. It's what happens when a bold headline, a brightly colored graphic, a flashy illustration, or an intriguing photograph initially snares the eye and then compels the viewer to continue following a composition's visual cues as to where to look next, next, and next.

It all happens fast, this visual hierarchy thing, and it's very subtle. It's also extremely important because—as we all know—images, printed pieces, and Web pages have only a few short moments in which to call out for attention, to declare what they are all about, and to convince viewers to stick around long enough to comprehend a piece's message.

When working on a layout or an illustration, continually sit back from your work and evaluate its conveyances of visual hierarchy. Ask yourself, *Do certain elements of this piece need to be made larger, bolder, or more colorful in order to call for more attention? Do other elements need to be made smaller, lighter, and less colorful in order to bring less attention to themselves? What else can I do to give this piece a clean and clear sense of visual hierarchy?*

Visual hierarchy fails when elements of a composition fight for attention. A layout with a high-impact illustration, a bold headline, and oversized text, for instance, will tend to frustrate and repel most viewers—just as if these viewers were trying to listen to three loud voices speaking at once.

Does every design and work of art need to convey a sense of visual hierarchy? No. Some compositions are built around the idea of specifically *not* drawing the eye to a particular place or directing it anywhere. The paintings of Jackson Pollock are good examples of art that conveys little or no visual hierarchy.

Take note of the ways great artists and designers establish (or avoid) looks of visual hierarchy in their creations: notice, evaluate, learn, emulate.

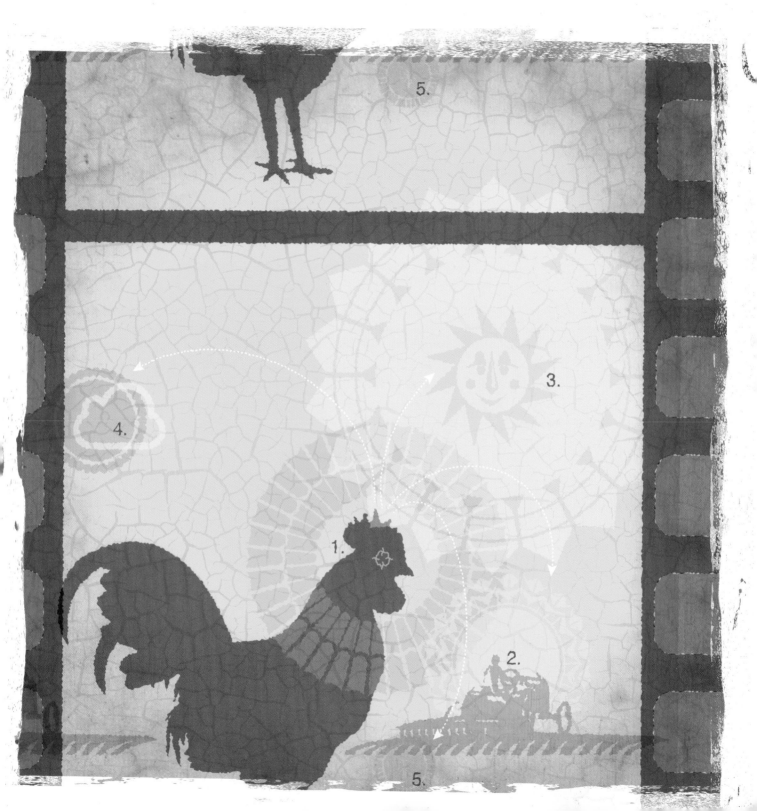

19 ASSOCIATIONS

Clear associations between certain compositional elements help establish a look of order and—to put it in plain language—help viewers understand what goes with what.

When centering a headline in the vertical space between an image and a block of text, for instance, the designer could place the headline nearer to the image than to the text. This would tend to imply that the headline is connected to—or even commenting on—the image's content.

The designer could also place the headline nearer to the text than to the image. This might suggest that the image is pretty much speaking for itself while the headline and the text are working together to confirm—and to expand upon—the image's message. Either approach could work: It's just a matter of deciding which solution seems to suit the project best.

And what about visually centering a headline between an image and the text? This is generally not a good idea since it might create a sort of visual tug-of-war between the photo above and the text below—neither seeming to have a dominant connection with the headline. (See Dynamic Spacing, page 30, for more about the potential disadvantages of dead-center placement.)

Train yourself to make conscientious decisions about the spaces that exist between *all* elements of a layout or an illustration. This may seem like a tall order—especially to those who are new to design—but once you start doing it purposefully it quickly becomes an instinctive habit. (And a very good habit at that: Details like these are critical when creating works of design and art that are to be as attractive and as communicative as possible.)

image

header

text

Headline

Lorem ipsum dolor sit amet, consectetur ad
isicing elit, sed do eiusmod tempor incididu
labore et dolore magna aliqua. Ut enim ad r
veniam, quis nostrud exercitation ullamco la
nisi ut aliquip ex ea commodo consequat. D
aute irure dolor in reprehenderit in voluptate
esse cillum dolore eu fugiat nulla pariatur. E
teur sint occaecat cupidatat non proident, s

20 FRAMING

Wood and metal frames draw attention to the works of art they hold by establishing a clear visual boundary between their art and the rest of the world. Most of the time frames are chosen based on their ability to complement whatever they enclose, but sometimes frames are selected to intentionally contradict the look of their contents in order to generate conveyances of humor, quirkiness, or intrigue.

Compositional frames (enclosures made using linework or background images, for instance, or openings that have been created within other components of a composition) can likewise draw attention to what's inside them by establishing a visual partition between the frame's content and surrounding material. And compositional frames— just like real-world frames—can be used to either boost or contradict the stylistic and thematic conveyances of their content.

Compositional frames can be geometric, freeform, simple, complex, ornate, or plain.

Naturally, not all layouts or works of art require that certain elements be compositionally framed, but there are situations where you can use visual aids of this kind to direct viewers' attention, bring touches of order, and/or to add notes of stylistic flair to chosen elements.

Compositional framing can also come into play—in very effective ways—when setting up photographic scenes. Many photographers actively seek points of view that will allow their main subject to appear visually contained within the form of something like a doorway, an opening beneath a tree, the blurred form of a distant landscape feature, or a happenstance gap in a crowd.

In fine arts, compositional framing happens a lot more often than you might realize. Take a look through an assortment of famous Renaissance paintings and you will find endless examples—examples that can both inspire and influence your own application of this useful visual strategy.

"Why is a raven like a writing desk?"

LEWIS CARROLL, *Alice in Wonderland*

21 GUIDING WITH COLOR

It is not absolutely necessary to employ color in order to direct viewers' eyes through a layout or an illustration: Viewers can be effectively attracted to—and guided through—black-and-white compositions through size relationships (see Visual Hierarchy, page 50), Dynamic Spacing (page 30), and well-considered value choices (page 122).

Color, however, whenever you apply it, can play a major role in boosting the ability of each of the above-mentioned compositional factors in attracting and guiding viewers' attention. Not only that, but color can be used entirely on its own to generate visual interest.

Bright and warm colors are generally considered more capable of capturing notice than cool colors, muted shades, pale tints, and neutral tones. This is demonstrated in obvious terms by the use of red, orange, and yellow for street signs that are intended to bring urgent attention to messages like *stop, yield,* and *caution.*

Cooler colors, muted shades, pale tints, and neutral tones are generally* less eye-grabbing than their warmer and brighter relatives. Hues such as these might be worthy of consideration for secondary components of a composition's backdrop panels, backgrounds, and borders.

If your palette-building confidence is lacking, consider spending extra time getting a grip on the material presented in Chapter 7, Color Awareness, and Chapter 8, Color and Conveyance. Also consider checking out this book's Creative Core companion volume *Color for Designers.* Color can be a mysterious and intimidating topic until you learn to break it down into its foundational (and easily understood) theories and principles.

*A color's ability to attract attention is always relative: Cool, pale, and muted hues are actually perfectly capable of calling for top-level attention—as long as they are surrounded by other hues that call for even less attention.

22 LINEWORK

Linework can contain. Linework can point. Linework can connect. Linework can surround an entire composition and/or particular elements within a layout or a work of art.

Brainstorm possibilities whenever you decide to employ linework. Lines can be geometric and precise, hand-rendered and casual, or graceful and ornate. Lines can be thick, thin, or any weight in between. Lines can be doubled, tripled, or more. Lines can be black, gray, colored, crisp, or blurred.

Linework, in graphic design, can also mean *lines* built from tiny dots, dashes, squares, or shapes.

Lines can also be used exclusively—or in part—to create illustrations. Line-rendered illustrations can be made from a single style of line or they can be composed of a mix of styles.

Illustrator, Photoshop, and InDesign offer an incredible range of options when it comes to linework. One good way of acquainting yourself with the options offered through these programs is to set up a blank document and to freely explore all kinds of ways of creating and using different styles of lines.

Linework is subject to the whims of popular fashion, style, and culture in much the same way as are colors, typefaces, and visual effects. This makes linework yet another item to pay close attention to as you keep your eyes on the work of leading designers of both today and yesteryear.

It is inhumane, in my opinion, to force people who have a genuine medical need for coffee

frothed milk

steamed milk

espresso

to wait in line behind people who apparently view it as some kind of recreational activity.

DAVE BARRY

23 POINTING ELEMENTS

Compositional elements like arrows, lines, triangles, and renderings of finger-pointing hands can be used to direct the eye toward chosen elements of a layout or an illustration.

You can use these visual pointers conspicuously, as with bold or brightly colored arrows to direct viewers' attention to specified elements of a layout or an illustration. Or even use arrows, triangles, and pointing fingers as starring elements of works of design and art—when circumstances call for such things.

You can also use pointing elements to subtly direct the eye. An elegant typographic flourish in the midst of a busy layout, for example, might discreetly carry viewer's attention from one region of the composition to another. A gesture or a gaze from a person within an illustrated or a photographed scene could also gently route the eye toward a significant compositional element.

The lines of perspective in dimensional works of art have long been employed in almost subliminal ways to direct viewers' attention toward critical components of compositions (perspective is covered briefly on page 110).

If you really want to take an enjoyable and enlightening crash course on the art of directing the eye, spend some time looking carefully at the paintings of fine-arts masters. Follow the eyes of the women, men, and creatures in these works of art—follow the gestures of their limbs and bodies, too. Take note, also, of the way that background and foreground structures and lines of perspective direct the eye. (Leonardo da Vinci's *The Last Supper* is filled with plentiful examples of all of the above.)

A word of caution. Pointing elements create powerful compositional gestures: Take care not to inadvertently lead a viewer's eye out of a layout or an illustration by including pointing elements that convincingly direct attention outside a piece's borders and/or off the page.

24 FLOW AND CONTAINMENT

Visual flow is hard to define, but easy enough to recognize once seen or sensed. Flow, when called upon to do so and when done well, provides the eye with a pleasant and sensible ride through the content of a layout, an illustration, a photograph, or a work of art. Effective flow encourages the eye to circulate gracefully among a composition's primary elements.

Flow fails when the eye is attracted to unimportant areas of a composition, when the eye feels a tug-of-war between elements that compete for attention, when the eye encounters illogical visual blockages, and when the eye is sent charging off the page by elements that seem to be directing it outside a composition's boundaries.

Visual hierarchy (page 50) can aid flow by giving the eye cues not only as to where to enter a composition, but also how to comfortably move within it.

Work with color to emphasize the flow-producing effects of visual hierarchy by applying it in ways that further draw the eye logically through a composition's components.

Use linework and pointing elements (covered in the two previous spreads) to assist in establishing an efficient sense of flow by containing and directing attention in both obvious and covert ways.

Add attractively curvaceous or sensibly linear pathways built from lines or graphic elements (dots, geometric shapes, ornaments, and such) to a layout or an illustration for both decorative and flow-generating purposes.

Use the swoop, sweep, or curl of a decorative element (the ornate tail of a script letterform, for example) to fluidly direct attention away from the edges of a composition and back to a layout's more important elements.

Take another look at Vincent Van Gogh's *Starry Night*. That's flow.

When I am ... completely myself, entirely alone...or during the night when I cannot sleep, it is on such occasions that my ideas flow best and most abundantly. Whence and how these ideas come I know not nor can I force them. WOLFGANG AMADEUS MOZART

25 COVER AND INTERIOR CONNECTIONS

Whatever you design for the cover of a brochure or a promotional booklet should almost always find itself visually echoed within the piece's interior.

Seems obvious, but it's amazing how often you come across brochures and booklets whose exteriors seem to have been conceived and created in a reality completely removed from the one in which their interiors were born.

There are all kinds of ways of establishing connections between a piece's cover and its interior. Typefaces, colors, graphic elements (linework, borders, backdrops, and so on) that appear on the cover of a multi-page design can be echoed throughout the piece in either clear-cut or understated ways.

Finding just the right amount of echo between a layout's exterior and interior panels is an art within an art: It's the process of establishing just the right degree of connection between two or more compositions (cover versus interior pages) that each have aesthetic and functional purposes of their own.

Bear this in mind from the beginning of any project that calls for a visual connection between outside and in. Not only will an awareness of this goal help you evaluate ideas in terms of their ability to connect a design's cover with its interior, it will also help you avoid spending excessive time on ideas that will likely lead to dead-ends if they don't end up connecting.

66 | CHAPTER 4

Delivering
Visuals

26 GRAPHIC SIMPLIFICATION

It doesn't take much to convey the idea of a star. Or a flower. Or a cat or a car. A few lines—straight and/or curved—could be all that's needed. Or maybe just a simple combination of basic shapes. You could always do more if you wanted, but when you get right down to it, it doesn't take much simply to communicate the visual essence of a person, place, or thing.

Simplified depictions of subjects are often used as elements within logos or informational graphics. Depending on how they're crafted, basic renderings of this sort might come across as utilitarian, fanciful, childish, crude, or elegant.

Apply everything you know about composition every time you work on a graphic image of this sort. Consider visual hierarchy, balance, flow, symmetry, asymmetry, color, and style. And, by all means, spend an adequate amount of time in the thumbnail stage when coming up with graphically simplified visuals—

there's rarely a good reason to turn on the computer before you've penciled at least a page or two of ideas worthy of digital attention.

Try this when developing the look of a simplified icon or graphic: Go too far. Oversimplify. And once you've gone too far and oversimplified your subject's form to the point where it's becoming difficult to identify, begin adding the details or embellishments that are needed to convey the look and the stylistic feel of whatever it is you're depicting.

The ability to produce quality graphics of this kind is expected of most professional designers. If you do not yet consider yourself talented in this area, practice. On your own and for fun. That way, when you're asked to come up with a graphic simplification in a potentially stressful on-the-job situation, you'll be able to work with a good measure of confidence and with a few tricks already up your sleeve.

Figure 1: Star

Figure 2: Flower

Figure 3: Cat

Figure 4: Car

27 BUILDING WITH SHAPES

One effective—and surprisingly fun—way of coming up with a graphic simplification of a person, place, or thing is to build your subject using a visual vocabulary of basic shapes: squares, circles, rectangles, ellipses, triangles, stars, and/or polygons.

Building illustrations or icons of real-world subjects using basic shapes can lead directly to usable results or it could provide a strong start toward an image that departs from a purely shape-based structure.

Abstract icons, too, can be developed very effectively using basic geometric shapes—especially when tools like those found in Adobe's Pathfinder panel are involved (available through Illustrator and InDesign).

The Pathfinder panel offers the tools-of-choice that many designers turn to when creating either representational or abstract icons from basic shapes. If you aren't already familiar with these tools, become so. And do it as soon as possible. Pathfinder tools give the designer a fantastic range of options when merging, subtracting, or finding interesting intersections between shapes. You can use Pathfinder tools to sculpt both simple and complex renderings from shapes of any kind.

On a related note, you can create intriguing and attractive visuals by forcing graphically depicted subjects to fit within—and to conform to—a geometric shape. Challenge yourself, for example, to develop an icon of a thing or an animal that fits neatly into a circle, an ellipse, a square, or a triangle. Designers often do this when crafting logos: Take note of examples of this kind of thing when you come across them and gather ideas for your own work.

Representational *figures*

figures
Non-representational

28 THEMATIC IMAGERY

Whether you realize it or not, every logo, illustration, or image you create emits conveyances: intangible themes like strength, creativity, order, precision, antiquity, and grace.

It's important to avoid letting these thematic conveyances happen willy nilly. Take control: Identify the themes you want your logo, layout, or illustration to deliver to its target audience and then get down to business creating a piece that not only looks good, but also accurately conveys the abstract inferences you're aiming for.

In the graphic arts, themes could be thought of as descriptors you would like to see associated with the company, person, product, or message your creation is connected with. Six such descriptors are listed in this column's first paragraph. Here are some more: elegance, brawn, gentleness, hi-tech, depression-era, futurism, fragility, exuberance, speediness, solidity, efficiency, casualness, urbanity, childishness, orderliness, retro-kitsch, and back-to-nature.

Half the battle, when it comes to identifying and delivering meaningful thematic conveyances, lies simply in acknowledging that these abstract entities exist and that they are crucial components of any effective work of design or art. Once this has been taken care of, it then becomes a matter of accepting your responsibility as a designer and finding ways of giving form to these non-tangible conveyances through well chosen typefaces, colors, and imagery—as well as through canny choices involving the compositional and stylistic appearance of your creation.

Write down relevant themes the next time you begin a design project. Come up with lists of on-target adjectives and use these lists to help judge the visual and stylistic choices you make while working. Not only will this streamline decision-making processes as you explore options, it will also help you come up with a legitimate rationale for the content and the appearance of your logo, layout, or illustration—a rationale that your client might enjoy hearing.

29 EFFECTS

Eye-catching special effects were once only available through time-consuming darkroom magic or the hands of a skilled illustrator. These days—thanks to the digitization of art media—things like drop-shadows, transparency effects, and dimensional treatments are each just a menu selection away. And those are just the tip of the digital effects iceberg.

It's rarely mandatory to apply effects of any kind to a layout's components (or to a layout as a whole) but effects are often worth considering. Sometimes, just the right special effect turns out to be exactly what's needed to add a perfect finishing touch to a composition's visual impact or its conceptual message.

Learn about the effects available through programs like Photoshop, Illustrator, and InDesign by playing with them. For most visually oriented people (designers, illustrators, and artists included) there's simply no better way to become acquainted with digital effects than by opening a document (a blank document, a photo from your hard drive, a custom-made illustration—it's up to you) and freely exploring your program's offering of special effects. The lessons learned during this digital playtime will almost certainly come in handy—and probably sooner than later—for real-world on-the-job projects.

All special effects are subject to the whims of fad and fancy—every bit as much as typefaces and color schemes. Drop shadows, for instance, regularly cycle in and out of favor among both designers and audiences. And not only that, but even when drop shadows seem especially popular, it's generally only a few specific styles of drop shadows that seem to have the full approval of better designers and more discerning viewers. If you pay close enough attention to the work of leading designers, it won't take long before you see the truth in this. Same goes for things like transparency illusions, shine and shimmer effects, and emboss and bevel treatments.

74

30 REPRESENTATIONAL ART

Depictions of reality can be delivered straight up, as in the case of a tightly rendered illustration or a photograph.

Reality-based visuals can also be presented through stylized imagery. This is probably the widest (and most varied) category in which visuals can be placed—a category that includes contemporary modes of illustration and photography, impressionistic fine-art paintings, and era-based graphic depictions (think: flowing art nouveau designs from the 1930s, bold Soviet poster imagery from the 1950s, psychedelic album covers from the 1960s, and so on).

Depictions of reality can also be altered in ways that ensure the delivery of conveyances like surrealism, fantasy, humor, horror, or mystery.

Digital photography and image-altering software has made it easier than ever to create visuals of genres like these using the computer, though some artists still prefer to create their conveyances of altered reality using old-school media like paints, pencils, and inks (or the digital equivalents of these traditional tools).

Are you rendering a particular subject for the logo or layout you're working on? If so, don't settle on a specific approach until you have considered your options. Look through illustration and design annuals for ideas. Look through art history books, too. Even the best illustrators regularly survey material outside their own portfolio for ideas and inspiration.

Do you possess the skills necessary to illustrate your subject as you see fit? If *yes*, then go for it. If *maybe*, then how about taking a stab at it and possibly spending some time off-the-clock teaching yourself the required skills? If *no*, then start looking for an illustrator who can pull it off for you— budget permitting.

31 PHOTOGRAPHY

In case you haven't already noticed, good designers often make good photographers. Good designers have an acute eye for composition, are able to see the aesthetic and communicative potential of subjects as unalike as a crumpled piece of paper and a setting sun, and—in many cases—also possess a strong and practical understanding of Photoshop.

78

Advice: Learn by doing. Make a habit of keeping a pocket digital camera on hand and taking pictures of the people, places, and things that catch your eye and prick your interest. And, very importantly, aim for a wide variety of photographic outcomes by exploring your camera's buttons, features, and settings. Also, needless to say, put your savvy sense of composition to good use by seeking points of view that will record every subject and scene you shoot in an intriguing and attractive way.

Once you get in the habit of regularly snapping good looking photographs, your stash of ready-to-use images will grow quickly. Designers with a strong cache of photos invariably have several favorites within their collection—photos that are just waiting to serve as foundational images for works of design or art. A strong stockpile of photos also will provide attractive options for layouts in need of anything from a colorful backdrop image of flowers to a featured shot of an emotive downtown scene.

Another thing that you can do with your digital camera is collect abundant photos of visual texture (see Visual Texture, page 102). You can shoot excellent representations of visual texture using subjects like an aged cement floor, a wall with cracked and peeling paint, a frost-covered windshield, or a drawer full of colorful buttons. You can then use these photos of visual texture as effective backdrops for layouts, illustrations, and Web pages.

32 CROPPING AND CONTAINMENT

Be sure to consider different ways of placing and containing the illustrations and photos that you add to layouts.

Images can be bled off the edges of a page, inset from a page's extremities, bordered by a line (thin, thick, black, white, colored, etc.), confined by an illustrated frame, enclosed with text, or wrapped with a decorative pattern.

The perimeters of photos and illustrations can also be darkened, blurred, or roughened as a way of establishing and emphasizing their outer edges.

Consider cropping, too—especially if you're working with photographs. Cropping can be slight or it can be severe, cropping can zoom in tightly on an image's essential component(s), or it can be applied in ways that leave areas of excess space within a scene (space that might or might not be filled with compositional elements like typography, graphics, or other images). Try several options before deciding what's best: Cropping can significantly affect the way any image presents itself.

If you're a designer who likes to shoot your own photographs (as mentioned on the previous spread), you'll be tempted to aim your viewfinder in ways that produce shots that are beautifully—and *tightly*—composed. Unfortunately, this otherwise good habit will allow few choices when it comes time to fit your photo into a layout that is calling for images of very specific proportions. The solution? *Shoot wide*: Pull back slightly from what you consider to be your shot's best composition and allow a bit of breathing room around its central area of interest. This excess room will increase your options when it comes time to crop the photo to fit within layout-specific spaces.

33 OBJECTS AS WINDOWS

82

Who says

only standard shapes

like rectangles, circles, and

triangles are fit to hold images or text?

What about using a freeform shape, a silhouette, or

a typographic form to hold a photo, an illustration, a

graphic, a pattern, a block of text, or an entire layout?

A potential for intriguing interaction exists when

shaped containers such as these are used as

holders for visual content: The container and

the content could agree in terms of thematic

conveyances—or they could intentionally oppose

one another in order to convey notions of humor,

silliness, or editorial-style commentary.

CHAPTER 5

Considering Style

34 CONSISTENCY

All designers, at all times, are capable of using exactly the skills they posses to create engaging and attractive illustrations. And while it's true that designers with limited art skills will be restricted in terms of the kinds of projects they can serve, this knowledge should never be construed to suggest that designers with a narrow range of rendering skills should automatically consider themselves unfit to play the role of illustrator when a new project lands on their desk.

After all, if things like crudely drawn stick figures, childishly rendered airplanes, and roughly sketched musical instruments can be considered stylistically appropriate and aesthetically effective visuals for certain projects (as such things regularly are—particularly within the context of contemporary media), then surely all designers should be able to match their illustrative talents to some jobs, at least some of the time.

One particular quality to aim for with your work—regardless of whether you're an accomplished painter, a talented digital artist, or a ham-fisted scribbler—is this: *consistency*.

If you're capable of painting with great skill, and are working on an illustration that is to be as classically and beautifully rendered as possible, then strive for a consistent pinnacle of grace and beauty with each stroke of your brush. If your skills are of the more casual and playful variety, and you're working on a digital illustration that calls for these qualities, then approach every detail of your creation with a consistent commitment to visual expressions of casualness and play. And if you're a designer whose illustration skills are still in the awkward stage of development, and you've been tasked with creating a spontaneous-looking, rule-breaking, stick-figure style rendering, then by all means, dive right in and consistently and enthusiastically apply exactly whatever arts skills you have to the job.

The advice I like to give young artists,
or really anybody who'll listen to me,
is not to wait around for inspiration.
Inspiration is for amateurs;
**the rest of us just
show up and
get to
work.**
CHUCK CLOSE,
artist

35 THE CHARACTER OF A CURVE

Whether you're developing a graphic simplification, a typographic character, an ornament, or an illustration, you need to be able to see, evaluate, and refine the look of your creation's curves. Though a seemingly small detail, the visual characteristics of the curves that inhabit your works of design and art will have a big impact on the piece's aesthetic and thematic properties.

As a basic example, say you are just sitting down to build a pattern out of a single wave shape. An excellent first step in this process would be to decide on the overall feeling you would like to see emanating from the pattern (elegance, formality, whimsy, and so on). Once this has been decided, you could then focus on coming up with a wave shape capable of projecting the chosen theme. Put full trust in your art instinct as you evaluate your options—there's no better way to decide what is right and what is not.

Take this step seriously: Your pattern's conveyances will be almost entirely dependent on the visual personality of the design's foundational wave shape—a shape whose character will be established by the curves from which it's formed.

This same sort of thinking can—and needs to be— applied to any illustration that includes curvaceous lines and shapes. Ask yourself, *What sort of visual personality should my illustration have? What kind(s) of curves should I use to bolster the piece's thematic conveyances? Should the illustration be built from curves with similar or varied characteristics?*

Every designer will answer questions like these differently, and there are many right answers. The most important thing here is simply that questions of this kind be asked in the first place. Otherwise there is a great risk of falling into either mental or digital default mode and either drawing—or letting the computer draw—the first curve that comes to mind (or to monitor). Don't let this happen to you: Explore your options before deciding on the character of your illustrations' curves.

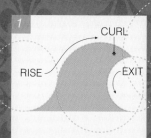

1. RISE · CURL · EXIT

Circular elements, tall form, large curl, steep rise, steep exit.

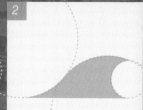

2. Circular elements, mid-height, gradual rise, steep and late exit.

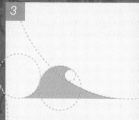

3. Circular elements, small size, compact curl, steep rise, sloping exit.

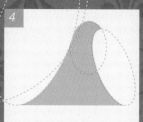

4. Elliptical elements. small curl, steep rise, steep exit.

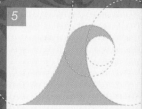

5. Elliptical and circular elements, tall curl, steep rise, steep exit.

6. Exaggerated precision, nearly complete curl, strong verticals.

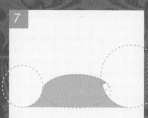

7. Ultra-squat proportions, steep rise, tiny curl, elliptical top, steep exit.

8. Rounded rectangular elements, overhanging curl, strong verticals.

Wave specimens, 1–12

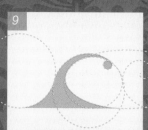

9. Delicate construction, decorative curl, arcing rise, swooping exit.

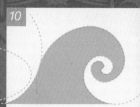

10. Curling form based on three golden spirals (see page 38).

11. Freeform construction, balanced flow, forward gesture.

12. Freeform construction, fanciful curl, playful conveyance.

36 APPROPRIATENESS

Harmony—when it's used in a conversation about aesthetics—is very often employed as a placeholder for words like *success*, *beauty,* and *perfection.*

For example, a book on painting might say, *A harmonious palette of vibrant hues has been used to add exquisite notes of color to the woman's dress.* Or an art director might say to a client, *The photograph and the typeface connect with perfect harmony.*

Using *harmony* in reference to aesthetic associations can make perfect sense. But it can also be misleading in a least a couple ways. For one thing, when most people hear the word harmony, they believe that it signifies *cordiality* and *friendly accord.* And this leads to the second problem—that harmony is so often referred to as a requisite of proper aesthetics that many designers seem to believe that harmony—a.k.a. *cordiality* and *friendly accord*—is a must when seeking associations between colors, typefaces, and imagery.

Nothing could be further from the truth. What about, for instance, a layout for a poster that's meant to convey itself with a bit more *bite* through inferences of conflict, danger, or angst? Wouldn't it be desirable in this case to consider associations between the layout's colors, typefaces, and imagery that intentionally provoke connotations of dissent and discord? And wouldn't a layout with these kinds of associations be every bit as capable of achieving exactly the aesthetic and conceptual effectiveness of a design with a more congenial message and look? Of course it would.

With this shortcoming in mind, consider removing (or at least limiting) the use of *harmony* in aesthetics-related discussions and thought, and replacing it with words and phrases like *appropriate* or *agreement of purpose.* After all, words and phrases like these fit all descriptions of aesthetic success—whether you're working on a piece that's meant to come across as cordial or one that's shooting for conveyances of a more trouble-ridden nature.

37 VALUE AND CONVEYANCE

Value in art is the relative lightness or darkness of a color or a shade of gray. And, as emphasized on page 122, value is responsible for providing the brain with practical information about everything the eye sees. When value fails, visual comprehension is lost—whether the eye is looking at a layout, an illustration, or a photograph.

Value also affects style. Designers and illustrators who assemble works of design and art without a keen awareness of value are like musicians who play their instrument without really caring what notes come out, or like chefs who prepare food with no regard for what flavors are produced. Value is that important.

Layouts and illustrations that are colored with hues that cover a wide range of values tend to deliver their thematic messages most emphatically. When bright colors are used in this way, strong inferences of youth, action, and vitality can be generated; when palettes of muted colors are presented in a wide range of values, connotations of sophistication, urbanity, or nature tend to come across with a solid sense of well-considered complexity and authority (keeping in mind that the exact connotations of any palette depend on the specific colors being used and the imagery to which they are applied).

Palettes built around hues that are mostly or entirely constrained to the lighter end of the value scale can effectively deliver themes that call for refined or conscientious handling: elegance, nostalgia, or maternity, for instance.

Moods ranging from opulence to mystery to menace can arise when the values in a layout or an image are constrained to darker values—and again, the specific colors being used will determine the precise thematic conveyances that arise: A set of dark and intense colors like royal blue, dark burgundy, and deep violet, for example, might carry itself with projections of rich history and regality, while deep and muted versions of the same hues might come across as edgy or even sinister.

38 THE STYLES OF OTHERS

Designers—especially those who want to serve a wide range of clientele—need to figure out ways of putting themselves in a variety of creative modes so they can aim for the stylistic preferences of a multitude of target audiences (see Evaluating Audience, page 172).

Designers who prefer gritty and disorderly layouts and illustrations, for instance, need to be able to take on a more crisp, clean, and conventional aesthetic outlook if they want to produce the kinds of layouts being sought by certain formal-minded clients.

And, conversely, designers who are partial to visuals of the more straight-laced and conservative sort need to willingly embrace aesthetics of a less rigid nature when working on projects for clients who are seeking qualities like originality and rebelliousness over attributes like conformity and orderliness.

Interestingly, a lot of designers seem to either miss this point or are put off by it: That in order to serve a wide range of clients, they need to be open to creating art in a wide range of visual voices—feminine, masculine, corporate, grass-roots, refined, rowdy, elderly, young, and so on. It's important—for the sake of job security, if nothing else—not to miss this point and not to be put off by it. And why not? Because it's reality. And also because being a designer can be a lot more fun once you learn how to use colors, typefaces, and visual styles in ways that appeal to people with whom you thought you had nothing in common.

How about you? Need to expand your artistic repertoire to include fresh styles and visions? How about spending some time looking through design and illustration annuals and boning up on the specifics of unfamiliar genres? And, by all means, how about answering with an emphatic *yes* the next time someone asks you to create a layout or an illustration with a look that is outside your stylistic norm?

TODAY'S STYLE OF ILLUSTRATION

39 MIXING IT UP

Several specific and semi-specific aesthetic categories are talked about in this book: graphic simplification, stylistic enhancement, realism, semi-realism, and altered realism, among others. And each of these visual modes can be generated using paints, pencils, cameras, and digital media (itself a category that includes endless options).

You can employ singular stylistic approaches—and specific mediums—to create works of design and art.

You can also use conglomerations of unrelated styles and media to produce visuals—especially when aiming for contemporary conveyances of diversity, quirkiness, kitsch, commentary, or chaos. When working on a project that calls for conveyances such as these, ask yourself, *Should I limit myself to just one style and one media or should I open things up to a jumble, patchwork, medley, mélange, potpourri, bricolage, gallimaufry, salmagundi, hodgepodge, or hash of approaches?* (Or something along those lines, anyway.)

It's particularly important to be decisive when mixing different styles of illustration and/or photography: *Decisively* choose to mix styles that either clearly have some kind of connection between them (a juicy watercolor illustration paired with inky calligraphic lettering, for example) or *decisively* choose to intermingle styles that are clearly unalike (as seen in the blend of imagery at right). This advice holds true whether you're combining visual styles to build a stand-alone illustration or sprinkling different kinds of images throughout a layout.

Amalgamations of visuals that are not either clearly alike or clearly unalike tend to fail because they leave the viewer wondering about the intentions of the designer and whether or not the slight discrepancies in the looks of the different visual material was intentional or not.

40 CONVEYANCES OF ERA

nce we get older than a dozen years or so, most of us have already begun attaching fond feelings and fanciful notions to certain eras of both the past and the (anticipated) future: The age of medieval chivalry is one example of an era that many people identify with in one way or another, as are the roaring 20s, the hardscrabble 30s, the flower-power 60s, the big-hair 80s, and yet-to-come epochs of exotic technology, fashion, and human achievement (or lack thereof).

Designers targeting certain groups of people—both large segments of the population and small niche groups—can charge their work with conveyances from eras such as these to help deliver visual and thematic messages in intriguing ways. This can be done through carefully selected typefaces, colors, photos, illustrations, design motifs, or all of the above.

Aiming for inferences of a specific era is hardly an approach that's suitable for all design and illustration jobs. But when it does suit a particular project, it's a tact that can be very effective. So effective, in fact, that it's worth taking a least a few moments to consider whether or not the ad, brochure, poster, website, logo, or packaging design you're working on might benefit from this kind of presentation.

Do thorough research if you decide to pursue a layout or an illustration that contains visual or textual material from another era. The Web, of course, is an excellent place to start when looking for images and information of this kind. Libraries and bookstores, too, might be helpful, and not only that, they might have a surprising amount of material that (believe it or not) cannot be found online. Research your chosen era carefully so that your work of design or art will accurately capture the subtleties of the look you're aiming for: It's not unlikely that the target audience for your creation will contain more than a few members who will be able to knowingly judge the authenticity and accuracy of the piece's era-based details.

CHAPTER 6

Entertaining the Eye

41 VISUAL TEXTURE

What is visual texture? For one thing, visual texture can be the rough, grainy, ridged, or cloth-like appearance you can add to a layout or an illustration using rendered or photographed imagery or through digital effects. Visual texture can also be dense conglomerations of any kind of abstract, representational, organized, or random visual material (lines, shapes, dots, dashes, curves, squiggles, ornaments, drawings, images—you name it).

Designers often employ visual texture to generate tactile impressions that bolster themes like ruggedness, coziness, or luxury. They might also use visual texture to deliver non-tactile conveyances like technology, kitsch, or spirituality.

Designers frequently add visual texture to the background of layouts. Or they might include it in otherwise blank areas of a composition—or added around a layout's perimeter—to provide notes of aesthetic and thematic interest.

Logos, illustrations, and graphics can benefit from the addition of attractive and thematically relevant visual texture—as can brochures, posters, stationery, business cards, websites, packaging, and signage.

You can also use visual texture to alter the look of images in interesting ways. Try adding an image of visual texture to a layer of its own over the top of a photograph or an illustration in Photoshop. Then apply different blend mode and opacity settings to the textural layer and see how the image beneath is affected. The outcomes can be highly intriguing and effectively mood altering—enough so that you might be inspired to start building up your own collection of visual texture images for this kind of use in future projects.

It's far from mandatory to include visual texture in every work of design and art you create, but it's surprising how often it can provide just the touch needed to lift the look of a layout or an image a notch or two higher on the scales of eye-catchiness and intrigue.

42 REPETITION

When the eye takes note of a pattern built from duplications of a shape, it generally recognizes—more or less instantly—that it doesn't need to explore every inch of the design in search of meaning since the pattern is unlikely to contain anything other than identical shapes, over and over (more about patterns on the next spread.)

Patterns provide a good example of how you can employ repetition to create visuals that are intended to go relatively unnoticed—visuals that are put in place to unobtrusively set the stage for elements that are meant to call for greater amounts of attention.

You can also use repetition in the opposite way: as a means of attracting notice and entertaining the eye. This you can do by featuring photos or illustrations that include unlikely and eye-catching duplications (or near duplications) of people, animals, or objects. Viewers are attracted to this sort of thing simply because life experience teaches us that improbable occurrences of repetition in real life are generally worth a second look. (Ponder, for example, how your reaction to seeing a solitary businessman at a bus stop would differ from your reaction to seeing three identical businessmen standing side-by-side at the same bus stop.)

Whether you're working on an ad, a brochure, a poster, or a website, consider employing repetition to create subtle backdrop patterns, and also think about using quirky, humorous, offbeat, or weird instances of repetition to entice viewers to fully engage with a piece's content and message.

43 PATTERN

Digital tools have made it very easy to build patterns from all sorts of visual material. Patterns can be fun to make, too, and they have all kinds of potential for use in design and art projects.

You can generate patterns from repetitions of shapes, arcs, swirls, typographic characters, dingbats, ornaments, and images.

A pattern's components can be rendered neatly or crudely, they can be distributed in orderly or rambunctious ways, and they can be created with or without special effects (drop shadows, emboss treatments, transparency effects, and so on).

You can fill entire backdrops—or just a few of a layout's interior panels—with one or more pattern designs. You can place patterns within or around graphic elements like headlines, silhouettes, and borders.

Use patterns to echo and boost the thematic conveyances of a layout—as in the case of an ornate pattern of classical filigree being used as a backdrop for beautiful script typography. You can also employ patterns to contradict a layout's thematic message—as when a pattern of classical filigree is used as a backdrop for graffiti-like lettering.

Learn to make patterns of your own using software like Illustrator. Borrow the elements for your pattern from typefaces, image collections, or your own cache of illustrated and photographic material. Or, compose your pattern from scratch by creating its elements by hand, with your camera, or through the tools offered through Illustrator's Pathfinder panel. The possibilities of pattern creation—even when limited to one or two pattern-making components—are literally without end.

A tip: Always create your patterns larger than you think they need to be. It can be a real bummer to spend time creating a pattern only to discover that it doesn't quite fill the space it was intended to occupy (and adding real-estate to existing patterns—as you may have already discovered—is not always an easy thing to do).

44 DEPTH AND ILLUSION

Two-dimensional depictions of depth have always held strong potential for attracting attention and entertaining the eye. Maybe this is because the novelty of three dimensions being portrayed within just two never quite wears itself out.

108

Programs like Photoshop, Illustrator, and InDesign offer plentiful tools and treatments that you can use to generate shadings, shadows, sheens, highlights, and structural forms that convey illusions of depth.

Want to get to know these tools and treatments? Open up a blank document and start exploring: Apply all kinds of dimensional effects to shapes, letters, and illustrated material. Hands-on learning like this not only allows designers to discover the capabilities of their software, it also tends to deliver information and ideas to the creative brain in ways that are much more clearly remembered than lessons learned from written manuals.

Also employ digital tools and treatments to establish notions of depth in very subtle ways. Use transparency effects, for example, to layer shapes, typographic elements, and images— one on top of the other—in ways that imply a subdued sense of under and over without really depicting firm notions of real-world dimensionality.

And don't forget more traditional means of adding illusions of dimension and depth to a design or an illustration: How about drawing eye-fooling optical illusions from scratch (a Celtic knot is one example of this sort of thing, as are reality-bending drawings created in the manner of M.C. Escher).

45 PERSPECTIVE

Do you know what vanishing points are and how to use them? The differences between single-point, two-point, and three-point perspective? The distinctions between isometric and optical perspective?

If yes, great: You know what most commercial designers and illustrators from yesteryear needed to know in order to generate looks of perspective through their hand-rendered graphics and illustrations. And not only that, you also have at least a fair understanding of what's going on beneath the hood of the software you use to create illusions of depth.

If not, how about sharpening your knowledge of visual perspective? It's know-how that will almost certainly come in handy throughout your creative career. An understanding of how visual perspective works will help you create convincing dimensional illustrations and graphics on-the-fly using either hands-on or digital media. Knowledge of perspective will also help you understand and evaluate what your computer

is doing when it's producing dimensional images and effects.

Visual perspective is much too large a subject to cover in this chapter. The good news, however, is that help on this topic is very easy to find: Look online or visit a library and/or a bookstore and you will find plenty of books (and chapters within books) that cover the rules and the tricks of perspective. Also, know that the fundamentals of vanishing points, horizon lines, and isometric and optical perspective are really not all that difficult to grasp—and that even a basic knowledge of these things is more than enough to boost one's ability to create and evaluate dimension-implying images.

As a side note, a nice bonus of learning about traditional techniques of conveying perspective is that it usually involves using non-digital tools like pencils, paper, rulers, and erasers. Fun work for designers and artists of the digital age. Try it. You'll see. Especially if it's been a while.

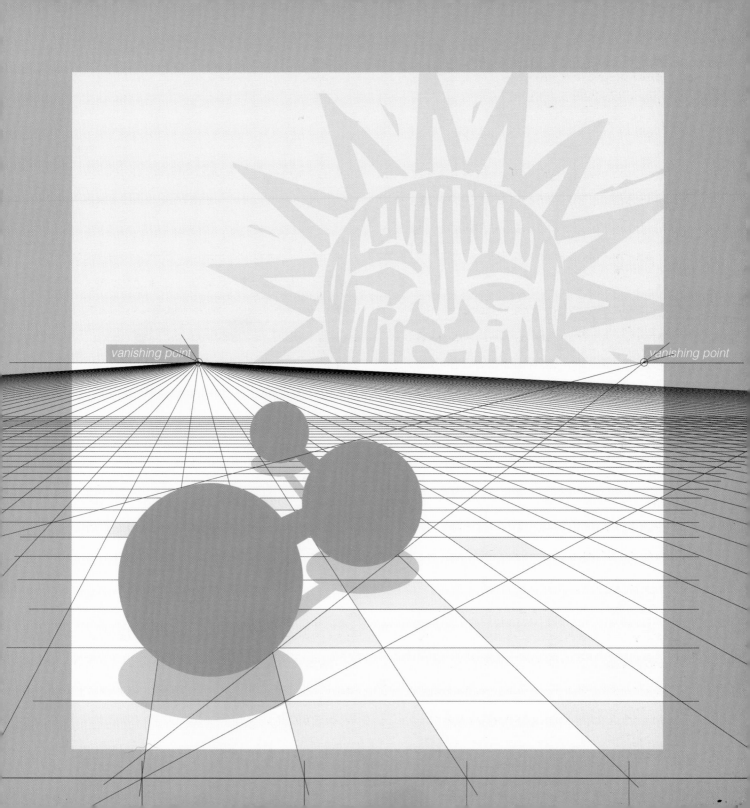

vanishing point

vanishing point

46 CALLOUTS

Callouts are the (usually small) labels and bits of text that are sometimes added to illustrations, schematics, maps, and photographs in order to point out details and to provide information.

Callouts—as you may have already experienced on a personal level—are hard for the eye to resist. Given the choice, many viewers go straight to these informational tidbits before reading the text of an article, an ad, or a brochure. Within a layout those callouts may be the only thing that gets read at all when a viewer is hurriedly scanning the content of a piece that includes labels or captions of this kind.

A callout can be a single word, a sentence, a paragraph, or an entire story. Callouts can be used to convey essential information to viewers. Callouts can also be employed in more casual—or even nonsensical—ways for the purposes of entertainment or intrigue.

Truth be told, callouts can also be invited into a layout or an illustration simply to spice things up with the bursts of color within—or the cleverly designed shapes of—the containers that are used to hold their text.

Brainstorm options whenever adding callouts to a layout or an illustration: Consider a variety of enclosures and backdrop treatments for these compositional elements. Try out different typographic presentations of the text they hold and think about whether or not the callouts should connect themselves with the visuals they caption with lines, leader dots, or arrows.

eyelashes

sclera

{ *eyelids* }

caruncle

iris

pupil

anatomy
of the eye

47 INTENTIONAL CHAOS

Some people are authentically attracted to chaos on a regular—if not a continuous—basis.

Others are attracted to chaos only some of the time, and only when it seems like chaos of the safe and sane variety.

And then there are those who avoid chaos in their actual lives, but are entertained and intrigued by works of art, cinema, and music that present conveyances of chaos from what feels like a safe distance.

If combined, it's likely that these three groups of people would amount to a large majority of the world's population. Not a bad target audience, wouldn't you say, for projects of art or design that seem like good candidates for deliverances of visual pandemonium?

So how about it? What about uncorking some artistic and conceptual mayhem and letting the components of your layout or illustration run wild—at least once in a while and when called for?

And when you do shoot for free-for-all conveyances of visual anarchy, remember that there are at least three kinds of chaotic compositional presentations: those that achieve their look of mayhem by embracing random compositional accidents (think: *Jackson Pollock*), those that—surprisingly enough—actually adhere strongly to aesthetic considerations like visual hierarchy (page 50), flow (page 62), and balance (think: *Joan Miró*), and those that include both random and controlled visual elements—as seen in the illustration at right.

CHAPTER 7

Color
Awareness

48 COLOR PERCEPTION

Give people a piece of paper, ask them to color the sky, and, chances are, they'll reach for a blue crayon.

Sure, the sky can be blue, except when it's a deep shade of violet, a bright red, a vibrant green-gold, a pale yellow, a dusty mauve, or any other color of the spectrum. It all depends on external influences like time of day, quality of light, purity of air, and whether or not the viewer is wearing sunglasses.

All kinds of assumptions are made about color: *The sky is blue, the sun is yellow, the clouds are white, the dirt is brown, and the trees are green.* But what are the real colors of things? How does our perception of these colors change when it is affected by different qualities of light and when certain colors are placed in proximity with certain others?

Artists who strive to paint accurate representations of real-world scenes struggle moment-by-moment with

questions like these as they ask their brains to let go of what is *believed* and to grasp, instead, what is actually *seen*.

As a designer, be prepared to do the same: to throw away much—or pretty much everything—you think you know about color and to cultivate instead the ability to see colors for what they are within different contexts.

And not only that, also open up your brain to the possibilities of using color in unorthodox and innovative ways to convey ideas and emotions to the viewers who will be looking at your works of design and art.

Color awareness and a savvy sense for applying color to works of art and design can be achieved through persistent efforts of observation, learning, and practice.

49 HUE, SATURATION, AND VALUE

If you really want to come to terms with how colors are perceived and how they can be selected, altered, applied, and combined, it's helpful to break things down into simple and easily understood color theory components right from the start.

Three components, in fact, are all that are needed to comprehend and describe the quality of any color: hue, saturation, and value.

Hue is just another word for color. Blue, yellow, and red are hues, as are green, orange, violet, chartreuse, salmon, periwinkle, and pumpkin.

Saturation refers to the intensity—or the purity—of a hue. A fully saturated hue is a color in its most intense and pure state. Muted or grayed-out versions of hues have lesser levels of saturation.

Value describes the darkness or lightness of a color on a scale that goes from near white to near black.

Hue, saturation, and value are each capable of contributing essential aesthetic and conceptual conveyances to the eye, but it's important to prioritize the role of value when choosing exactly which incarnation of each color (bright, light, dark, or muted) you apply to any layout or illustration: Value, as explained on the next spread, simply has to be consideration number one when applying colors to any work of design or art.

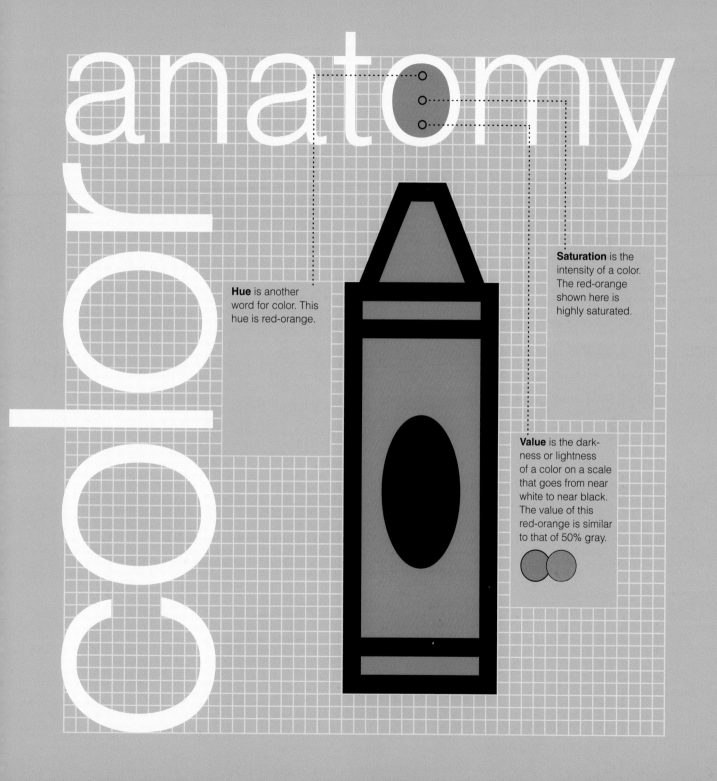

anatomy

color

Hue is another word for color. This hue is red-orange.

Saturation is the intensity of a color. The red-orange shown here is highly saturated.

Value is the darkness or lightness of a color on a scale that goes from near white to near black. The value of this red-orange is similar to that of 50% gray.

50 VALUE OVER ALL

It would be virtually impossible to comprehend the forms of the things we see—or to make out distinctions between one form and another—if everything we were looking at were the same value.

Why is this? It's because the eye relies on differences in value to make sense of anything we look at: Light, medium, and dark values (and all degrees in between) define and distinguish the forms of every person, place, animal, plant, or thing we see.

Hue and saturation are secondary visual factors simply because neither hue nor saturation can enter the picture (so to speak) without a value to latch onto. Value, on the other hand, can do a fine job of communicating visually without help from either hue or saturation. Want a demonstration of this? Look no further than a black-and-white image—an image that is made up of only values, and without a hint of either hue or saturation.

It's imperative, then, that designers and artists prioritize the role of value when applying colors to layouts, logos, and illustrations. The colors of our works of design and art simply can't be right if their values are wrong, and that's all there is to it.

Now, this doesn't mean that hue and saturation are unimportant. Not at all. Hue and saturation can be crucial, in fact, in delivering certain conveyances of beauty, style, and meaning. And it's the job of the designer, illustrator, or fine artist to come up with engaging and effective associations between value, hue, and saturation whenever applying color to their visual creations.

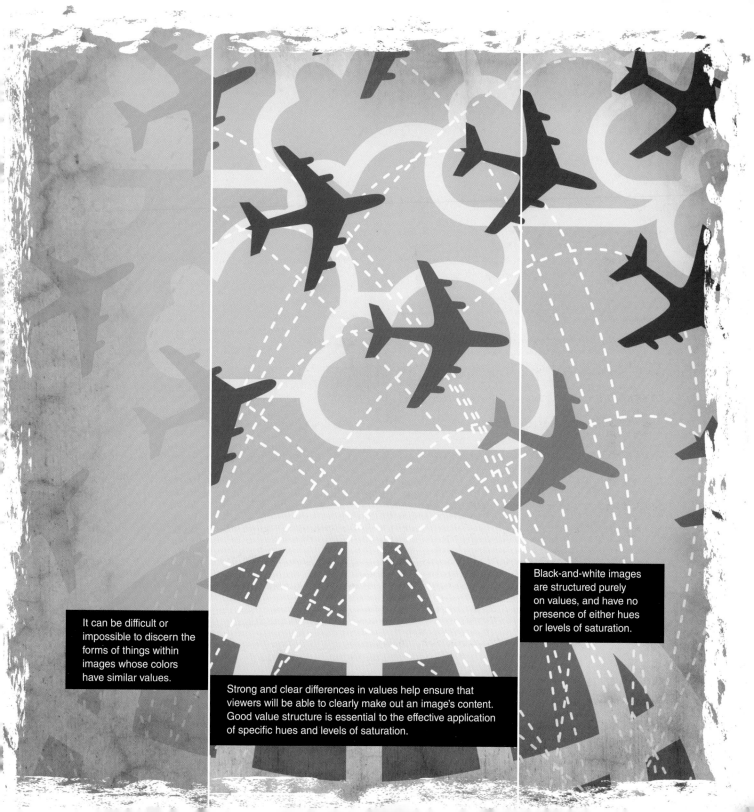

It can be difficult or impossible to discern the forms of things within images whose colors have similar values.

Strong and clear differences in values help ensure that viewers will be able to clearly make out an image's content. Good value structure is essential to the effective application of specific hues and levels of saturation.

Black-and-white images are structured purely on values, and have no presence of either hues or levels of saturation.

51 WHEELS OF COLOR

Color wheels are useful schematics that have been developed and embraced by both artists and scientists for centuries as visual aids that help explain and predict the way colors behave and associate.

The color wheel is usually represented by a circular twelve-spoke diagram that includes the primary colors of red, yellow, and blue; the secondary hues of orange, green, and violet (secondary hues are made from mixes of primary colors); and the tertiary hues of red-orange, yellow-orange, yellow-green, blue-green, blue-violet, and red-violet (tertiaries are produced when primary and secondary colors are combined).

Color wheels are usually presented with solid spokes of pure, intense hues. A color wheel can demonstrate the effects of value by featuring each of its slices as dark-to-light ramps of color. Levels of saturation can be conveyed through color wheels that display their spokes as gradients that travel from fully saturated to deeply muted hues.

It's not possible to convey all three qualities of color—hue, saturation, and value—through a single two-dimensional color wheel. To represent all three color components at once, two or more color wheels, a three-dimensional rendering, or an actual three-dimensional model is needed.

Colored light behaves differently than colored pigments. The color wheel of light features the familiar on-screen RGB hues of red, green, and blue as its primaries, and yellow, cyan, and magenta as its secondaries. Most designers find it difficult to think in terms of the RGB color wheel since we are traditionally taught to envision red, yellow, and blue as primary hues. This is not really a big deal since the colors in image-based software like Photoshop, Illustrator, and InDesign generally behave according to the pigment-based red/yellow/blue model of color theory.

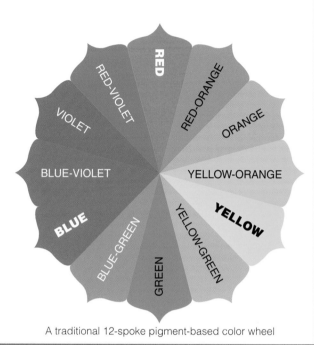

A traditional 12-spoke pigment-based color wheel

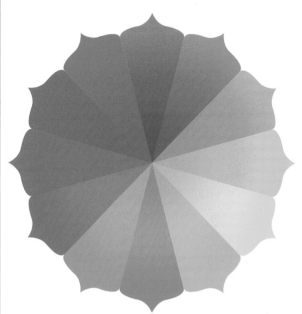

A color wheel that demonstrates differences in saturation

A color wheel that takes values into consideration

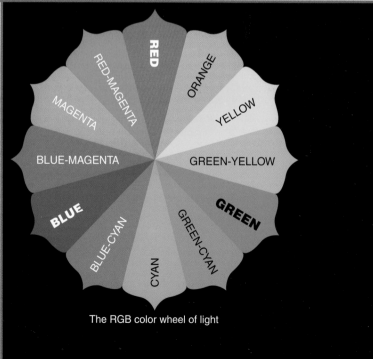

The RGB color wheel of light

52 COLOR ASSOCIATIONS

One of the best things about the color wheel is that it can be used as a visual reference when developing good-looking palettes. Each of the time-tested and artist-approved palettes featured opposite are defined according to the simple ways in which their hues relate within and among the spokes of the color wheel.

Familiarizing yourself with these color schemes will speed and expand your palette-creation process by breaking down color associations into easy-to-remember ideas and schematics.

Knowing how these palettes work will also simplify your understanding of how attractive and effective palettes can be created—and thereby removing much of the mystery and confusion you may currently feel when choosing colors for your works of design and art.

Try initiating your search for aesthetically pleasing and thematically on-target palettes through tried-and-true color combos such as these. At the same time, remember that this is only the beginning of the palette-building process: Dark, light, bright, and muted versions of each of a palette's members should be considered when finalizing the look of any color scheme (the next spread features thoughts and ideas about fine-tuning the look of a palette's individual hues).

An important thing to keep in mind when selecting specific colors for palettes such as these is that scientific accuracy is not a prerequisite: Trust your eye and your creative instinct to guide you to the exact incarnation of each color of any palette you build.

Five versatile palettes of color

Monochromatic palettes are made from different values of a single hue. This arrangement of values is based on a muted shade of the color wheel's blue-violet spoke.

Complementary pairs of colors are those that sit directly opposite each other on the color wheel.

Analogous palettes are based on combinations of three to five adjacent hues of the color wheel.

Split-complementary palettes are created when a color is joined by the two hues on either side of its complement. (Here, for example, blue is joined by the two hues on either side of blue's complement, orange.)

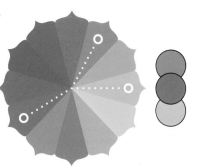

Triadic palettes are based on three equally-spaced hues of the color wheel.

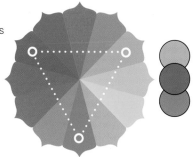

Important: When building any of the palettes shown here, know that any of these palettes' members can be altered and expanded into dark, light, bright, and muted versions of themselves without violating the definition of that palette.

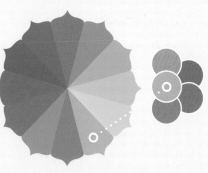

53 FINALIZING PALETTES

Say you've decided to apply a split-complementary palette to the pattern you're building from an assortment of decorative dingbats. You've chosen this kind of palette because of its sophisticated ability to convey thematic inferences of both harmony and contrast (*harmony* in that split-complementary palettes always include at least two hues that sit near each other on the color wheel, and *contrast* because they also feature a color that stands solo on the opposite side of the wheel).

Would it be enough to simply extract the hues for your split-complementary palette from the color wheel and plug them into your pattern? Doubtful… at best. It's far more likely that you'll want to make alterations to the value and/or saturation of one or more of your hues—and very possibly expand at least one of your palette's members into multiple monochromatic incarnations (illustrated on the previous page) of itself—en route to devising a color scheme that functions well and pleases your eye.

This is where the real work (and the real fun, too) of palette building takes place: the point at which you start looking at alternative versions—and expansions of—the individual colors of your palette. The computer can make exploration of this kind relatively easy and fast, and you'll want to become familiar with digital color-choosing aids like Illustrator's Color Guide and the Color Picker panel offered through both Illustrator and Photoshop (the next spread contains information about both of these digital color-choosing tools).

Over time, as your color-related instinct, knowledge, and confidence grow, you will likely find yourself increasingly able to come up with alternative versions of the colors you're applying to your layouts and illustrations with little or no help from digital aids such as these.

One thing you'll notice as you finalize the look of any of the palettes defined on the previous spread is that *there are really no bad combinations of hues—just poor applications of value and saturation*.

Good value structure (as mentioned on page 122) should be your highest priority when finalizing the specific hues of any palette. Seek differences in value that allow every element of your layout or illustration to stand out properly against every other.

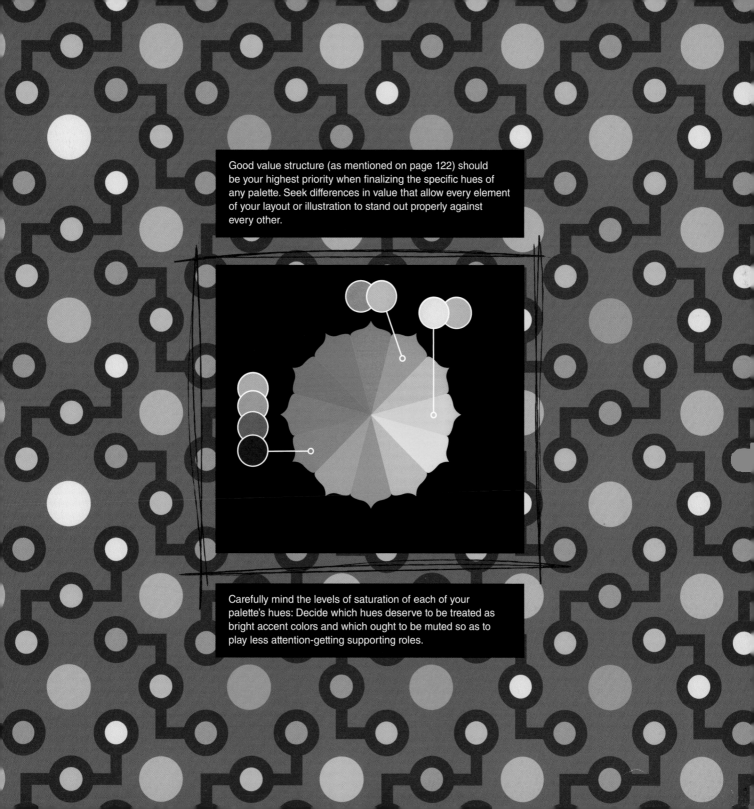

Carefully mind the levels of saturation of each of your palette's hues: Decide which hues deserve to be treated as bright accent colors and which ought to be muted so as to play less attention-getting supporting roles.

54 DIGITAL COLOR TOOLS

Illustrator's Color Guide panel and the Color Picker panel available through both Photoshop and Illustrator are extremely powerful and useful color-choosing aids. (InDesign offers a Color Picker too, but it's of a different sort than the one offered through Photoshop and Illustrator.)

130 You can load any CMYK or RGB color into these panels, and the program can generate lighter, darker, brighter, and more muted versions of the color for consideration.

When employing the Color Guide or Color Picker to come up with candidates for a multicolor palette for a layout or an illustration, try filling small squares with hues you favor—along with ones that seem to have at least a measure of potential—off to the side of your on-screen work area (or in a document of their own, if you prefer). Use these squares of color just as you would physical swatches of ink or paint: Move them around and next to each other in different ways, and evaluate how they associate in terms of their value, hue, and saturation. Once you have a set of swatches you're happy with, you can then either sample them with the program's Eyedropper tool and apply them to your artwork, or select the colors as a group and add them to the Swatches panel, where they can be accessed and applied to your work of design or art. (See these programs' Help menu if you are unfamiliar with how either the Eyedropper tool or the Swatches panel work.)

As your eye for color improves and your confidence at building good-looking palettes grows, you'll probably find yourself wanting to make minor or major adjustments to some of the specific color formulations offered through the Color Guide and Color Picker. This is a good thing, of course, since your own art sense should always make the final call regarding the precise look of any color you apply to layouts and illustrations.

Headline

Lorem ipsum dolor sit amet, consectetur adipis
sed do eiusmod tempor incididunt ut labore e
magna aliqua. Ut enim ad minim veniam, quis
exercitation ullamco laboris nisi ut aliquip ex ea
consequat. Duis aute irure dolor in reprehen
voluptate velit esse cillum dolore eu fugiat nulla
Excepteur sint occaecat cupidatat non proident, sunt in
culpa qui officia deserunt mollit anim id est laborum. Lorem
ipsum dolor sit amet, consectetur adipisicing elit, sed do
eiusmod tempor incididunt ut labore et dolore magna
aliqua. Ut enim ad minim veniam, quis nostrud exercition
ullamco laboris nisi ut aliquip ex ea commodo consequat.
Duis aute irure dolor in reprehenderit in voluptate veli
cillum dolore eu fugiat nulla pariat
occaecat cupidatat n

Color Guide

Sha... Tl...

None

Headline

Color Picker

Select Color:

OK
Cancel
Color Swatches

H: 12°
S: 85%
B: 89%
R: 227 C: 0%
G: 74 M: 85%
B: 32 Y: 100%
E34A20 K: 5%

☐ Only Web Colors

consectetur adipisicing elit,
cididunt ut labore et dolore
minim veniam, quis nostrud
nisi ut aliquip ex ea commodo
e dolor in reprehenderit in
olore eu fugiat nulla pariatur.
pidatat non proident, sunt in
llit anim id est laborum. Lorem
ctetur adipisicing elit, sed do
t ut labore et dolore magna
niam, quis nostrud exercitation
o ex ea commodo consequat.
henderit in voluptate velit esse
cillum dolore eu fugiat nulla pariatur. Excepteur sint
occaecat cupidatat non proident, sunt in culpa qui officia
deserunt mollit anim id est laborum.

132 | CHAPTER 8

Color and Conveyance

55 INTENSE PALETTES

Bright colors, intuitively enough, convey themselves with stronger inferences of visual charisma than muted hues.

Are you working on a project aimed at a youthful or an active audience? A poster for a grade-school stage production, a logo for a sports team, or a website for a travel and adventure club? If so, then a palette of intense hues might be just what's needed to infuse your visuals with the conveyances of energy and vitality you're looking for.

If you are using a palette of mostly—or entirely—saturated hues, and wish to amplify its conveyances of extroversion to the maximum, then build your palette around a range of values that spans all the way from very light to very dark. You can restrain inferences of exuberance, on the other hand, by limiting the value differences within a palette that contains intense hues.

With all this potential for visual effervescence comes a caution: Don't overdo it unless you really mean to. A common mistake among inexperienced designers is to create palettes of what appear to be off-the-shelf assemblages of bright colors—each of which seem to be shouting for viewers' attention, and none of which seem to be satisfied playing supporting roles within a composition (roles that could be nicely filled by hues that are muted either a little or a lot).

Successful palettes of intense colors are those that are applied to projects that call for them in the first place, and also to those that present their content through a value structure that establishes clear distinctions between individual hues. This is important with any palette, but it's especially true when intense colors are being used, since an uncomfortable optical effect—almost like a sort of visual buzz—can occur when highly saturated hues of nearly the same value touch each other.

Go. See. Do.

56 MUTING SOME, MUTING ALL

Seeking to generate strong hints of diversity, sophistication, and urbanity through the colors in your layout or illustration? Try going with a highly varied mix of saturated and desaturated hues— palettes of this kind can generate strong hints of diversification and worldliness through the wide range of looks conveyed through their individual members.

Looking for a way of quieting down the conveyances of energy being delivered through your palette's colors? Try muting all of its hues either a little or a lot, and also see if simply muting its brightest colors does the trick.

Want to help the bright accent color(s) of your layout or illustration stand out? Surround your accent color(s) with muted hues that are either notably lighter or darker in value (more on this on the next spread).

What happens when a bright hue is muted heavily? If the hue is a warm color, then it will become a shade of either brown or warm gray (a gray with a hint of brown, yellow, red, or orange). If a cool hue is heavily desaturated, it will become a cool gray (a gray that leans toward blue, violet, or green).

Adobe's Color Picker and Color Guide panels (see page 130) can usefully steer designers and illustrators toward muted variations of any hue.

Use a printed process color guide whenever possible when choosing muted hues (especially highly desaturated colors like deep browns or grays). Many computer monitors struggle mightily when it comes to producing accurate on-screen representations of hues like these. (See page 208 for more about this issue.)

Mostly bright hues (the pea green and light yellow are slightly muted)

All colors muted toward brown shades

All colors muted toward grays

Pink remains bright while other colors are muted

57 RESTRAINT AND PUNCH

Will a light and pale shade of yellow stand out if it's surrounded by intense shades of blue and magenta? Chances are, no. Not even close.

Will the same yellow call for attention if it is set against a backdrop of strongly muted blues, darkly burnished burgundies, and deep cool grays? It most certainly could—as evidenced by the illustration opposite.

The yellow used in this illustration (the very same yellow that colors the flag-waving figure above), though not a particularly bright hue, stands out among its surrounding colors simply because it's more saturated than the image's other hues, and because it's notably lighter in value.

When you look at the pale yellow figure above—sitting against a white backdrop—it doesn't actually appear all that bright—not nearly as bright as it looks within the illustration at left, anyway. The lesson here is that the ability of an accent color to provide visual punch has more to do with how much visual restraint is being shown by surrounding hues than it does with the intensity of the accent color itself.

(Why wasn't a brighter yellow used in this illustration to provide a more extreme example of visual pop? Simply because a brighter yellow would have presented itself in a way that would have seemed out of context with the nostalgic flavor of the illustration.)

Keep color temperature in mind, too, when looking for ways of helping accent colors stand out within a palette. Try surrounding warm accent hues with a predominance of muted cool colors and cool grays, and, conversely, try surrounding bright, cool accent colors with palettes of mostly or entirely warm grays and muted browns.

138

58 ENERGY THROUGH VARIETY

As talked about earlier in this book, variety among the compositional elements of a layout or an illustration generates inferences of energy—differences in size relationships and variances in spacing and alignment, for example.

You can also amplify conveyances of energy by combining fonts with more than one typographic voice (talked about on page 150) within a layout or a logo.

Palettes of color, too, can be used to amplify lively notions of action and diversity by emphasizing differences between its colors, hues, levels of saturation, and values.

Keep this in mind whenever you're working on colored layouts and illustrations. If you find yourself wanting to boost a piece's inferences of charisma, but don't want to make changes to its compositional or typographic components, know that adjustments to the piece's palette might produce exactly the theme-conveying results you're looking for.

And, on the other hand, remember that you can also chill things down—thematically speaking—by restraining the amount of variety among your palette's members (and also by muting some or all of its hues, as mentioned on page 136).

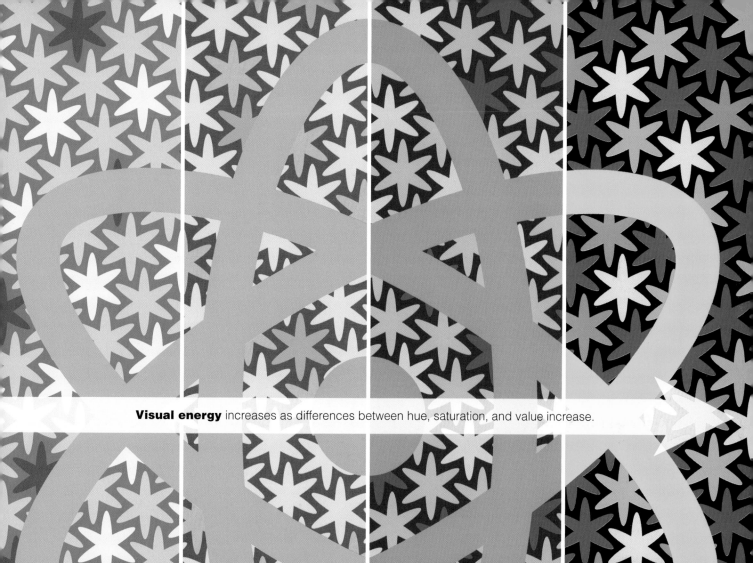

Visual energy increases as differences between hue, saturation, and value increase.

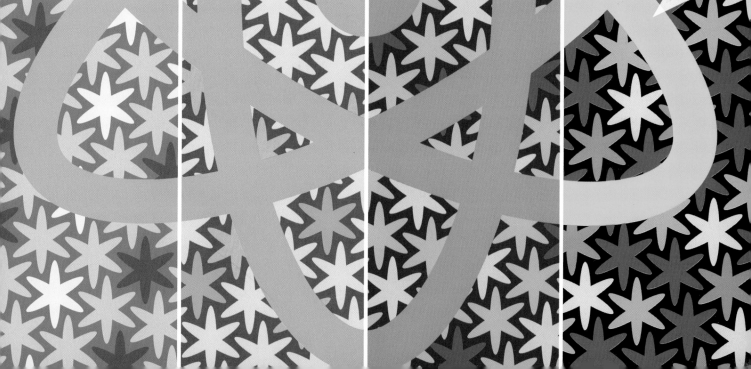

59 COLOR CONNECTIVITY

Not sure what colors to use to make sure your layout's backdrop, typography, border, and/or decor visually connect with the piece's featured photograph or illustration?

How about using the Eyedropper tool from within Photoshop, Illustrator, or InDesign to select and identify a specific hue from within your layout's image, using the color as the basis for one of the palettes described on pages 126–127, and then applying the colors to your layout's various components?

Or what about using the Eyedropper tool to borrow a whole palette of colors from your featured image, and then distributing the hues to the rest of the design?

Either method—or a blend of the two—can help produce a layout whose imagery and graphic elements share a strong sense of visual accord.

The computer makes this kind of color-sampling and color-applying very easy and quick, so be sure to try out several options before deciding what's most effective. Perhaps your layout will look best if prominent and obvious colors are borrowed from your layout's photo or illustration, and maybe you'd have better luck sampling some of your image's more discrete hues instead. Investigate the options and let your art-sense make the call.

One word of advice: Always be prepared to lighten, darken, brighten, or mute any color you borrow from an image in order to make sure the hue functions as it should within the context of the layout in which it is applied. The digital tools mentioned on page 130 can help you come up with just the right incarnation of any color you are thinking about applying to a layout.

60 WORKING WITHIN LIMITS

Designers and illustrators are often required to work with just one or two colors of ink (black plus a spot color, for example) as opposed to being able to choose from the many thousands of colors that are available when printing with the full range of CMYK color mixes (more about CMYK printing on pages 198–201).

Sometimes these restrictions involve working with a client's one or two corporate colors, or when trying to match the look of previous jobs that were printed with a limited number of inks. Also, there are situations when a client's printing budget simply won't allow for more than one or two colors of ink, and that's that.

In cases like these, it's our resourcefulness, our aesthetic and compositional savvy, and our compositional skills that can save the day as we strive to make much from little.

In terms of the colors you apply to jobs that are limited to one or two inks, what about choosing an especially expressive color for your design and applying it in an intriguing and eye-catching way? Maybe an uninhibited incarnation of orange or red, or a luscious shade of royal violet or periwinkle blue?

How about flooding your layout with an ink of an especially powerful hue and reversing some or all of your design's textual elements to white?

What if you broke down your one or two colors of ink into various lighter screens and applied these to your layout's elements?

The bottom line: Creativity, cleverness, and resourcefulness can always overcome shortcomings in print budgets. Learn to see situations like these as prime opportunities to flex your creative skills to their maximum—you might very well surprise yourself (and the client) with the results.

146 | CHAPTER 9

Typography

61 TYPES OF TYPE

Fonts can be divided into six main categories: serif, sans serif, script, blackletter, novelty, and dingbat. Here are a few words about each.

Serif (also called *Roman*) typefaces—as their name suggests—have serifs. Serifs are rectangular, tapered, pointed, rounded, straight, arched, thin, thick, or blocky shapes projecting from the end of a letter's stroke(s). The letters of serif fonts are almost always built from strokes of different widths.

Sans serif fonts are without serifs and are usually made from strokes of the same width. (Actually, if you look very closely at the letters of most sans serif fonts, you'll find that their strokes are subtly sculpted in ways that allow them to come across as being of a consistent width, when in fact they may not be.)

Script typefaces are usually broken down into two sub categories: formal and casual. Formal script fonts are based on hand-drawn cursive and calligraphic letterforms that have been rendered with grace, flair, and precision. Casual scripts have a more openly hand-rendered look about them, and their letterforms usually appear to have been created with a brush or a pen (rather than with a traditional calligraphic nib—as in the case of most formal script letters).

Blackletter fonts are based on the heavy, angular calligraphic letterforms often seen in manuscripts from the 12th to 17th centuries.

Novelty (also known as *decorative*) typefaces are pretty much any that don't fit into the categories mentioned above. A novelty font might contain decorative letters from an earlier era; it might be built from freeform or geometric shapes; it might have a dimensional appearance; it might be composed of characters straight from a 1980s dot-matrix printer; and it might look like it's been carved from wood, chiseled from stone, or scribbled by a child.

Dingbat and *ornament* fonts are composed of symbols, decorative designs, and illustrations.

Typographic Categories

Sample

Helvetica Bold

Sans serif

Sample

Futura Light

Sample

Garamond

Serif

Sample

Lubalin Graph Demibold

Bickham Script

Script

Mr. Sheppards

Fette Fraktur

Blackletter

Kingthings Spikeless

SAMPLE

Knox

Novelty

Kamaro Joy Slip

Zapf Dingbats

Dingbat

Franklin Caslon Ornaments

62 TYPOGRAPHIC VOICES

We've all heard the phrase, *It's not what you say, it's how you say it.* A similar sentiment applies to typography: It's not the words that are sitting on the page, it's how the words come across when they are set in Helvetica… or Klavika, Garamond, Bickham Script, Cezanne, Blackoak, Knockout Junior Flyweight, and so on.

Typefaces are like voices. Like inflection. Like innuendo. Like tone. Like volume. Like presence. Like implication.

Every typeface says things at least a little differently from any other, and people know this—whether or not they know they know it.

Designers must learn to see the differences between fonts and to hear the inflections that arise from various typefaces in order to choose ones that are able to clearly communicate not only their layouts' literal messages, but their desired thematic inferences as well.

How do you evaluate a typeface? You look at it. You look at the structure of the font—the qualities of its lines, curves, and embellishments (if any)—and you simply let the entirety of these visual characteristics translate themselves into the font's thematic voice. Sound like an abstract, touchy-feely, or right-brained activity? That's because it is any or all of these things—just like so many other creative activities you consciously and unconsciously handle when making decisions about the look, content, and coloring of the layouts you create.

Once you begin to narrow your search for a specific font for a logo, headline, or block of text, try applying your leading candidates to the actual words or text you'll be featuring. Seeing a font's letters in this way, and noting the thematic inferences that arise, will tell you a lot about how fitting or unfitting a particular typeface may be for the project you're working on.

63 TYPE AND TREND

If humans were machines, then yes, we'd probably need just one ultra-bold, condensed, sans serif typeface to inform us that we were being commanded to pay attention to an ad's urgent and essential message, and only one script font to let us know that a brochure's featured item was both elegant and exclusive.

But we're not machines. We're opinionated, fickle, perpetually morphing, living, breathing, and thinking creatures who get bored easily when faced with the same breakfast to eat, the same pair of shoes to wear, the same music to listen to, and the same typefaces to look at.

That's why trends arise, and that's also why we need to pay close attention to the ever-changing currents of fad and fashion—or else risk becoming one of those designers who uses typefaces (and possibly colors, linework, and illustrative styles) in ways that are out of step with what their target audience considers timely and attractive.

There is really only one way of keeping up with trends and changes in typographic styles (as well as with fashions involving other aspects of design like color, linework, and illustrative styles), and that's by paying attention. Simple as that: Pay close attention to the typefaces that the better designers are using, and also take a good look at the specific ways these art professionals present words and sentences through choices involving kerning and leading.

Design annuals are a great source for this kind of material: Immerse your eyes and your brain in compilations like these regularly and often.

Typography is a topic that deserves an entire book to itself. This chapter is meant merely to whet your appetite on the subject. If you want to delve deeper into typography, take a look at this book's Creative Core companion volume *Lessons in Typography,* scheduled for release in 2015.

YESTERDAY

TODAY

TOMORROW
(A FORECAST)

Typography

64 SEEING SUBTLETY

The differences between, say, a 1967 Ford Mustang and a 1968 Ford Mustang would probably be instantly recognizable to a person with a passion for classic cars. The differences between the two Mustangs, in fact, would likely be as significant to the aficionado of 1960s automobiles as they are insignificant, indiscernible—and even invisible—to the rest of us.

As designers, our enthusiasm for typefaces and letterforms should be at least equal to the feelings people have for any other passion-worthy subject. To feed and inform this zeal, we need to develop an astute eye for typographic subtlety—an eye that is able to see even the finest differences between fonts and the presentation of typographic material—while also grasping the aesthetic and thematic implications of these often tiny (and always important) details.

When it comes to finding distinctive features within individual typefaces, here are a few particulars that are especially worth scrutinizing. Look at a font's R and notice its tail. Where does the tail originate, where does it end, and how is it shaped? What about the capital O? Is it a perfect circle, an ellipse, an oval with vertical sides, or some other shape? Study the letter S. Does its curvaceous stroke begin and end horizontally, vertically, or at an angle? What do the font's lowercase a, g, and q look like? (Font designers often inject distinct notes of personality into these characters, as well as into the capital Q, question mark, and ampersand.)

If it's a serif font you're looking at, then naturally, your quest for familiarity with that typeface should begin with a look at the font's serifs. Are they rectangular, tapered, pointed, rounded, straight, arched, thin, thick, or something especially unique?

Also, it's clearly worth noting the easily seen overall typographic qualities of fonts that feature decorative add-ons, intentionally damaged or misshapen letterforms, and any other stand-out quality that establishes the font's look and feel.

Helvetica	R	o	S	a
Futura	R	o	s	a
Franklin Gothic Condensed	R	o	S	a
Reykjavik	R	o	S	a
Clarendon	R	o	S	a
Palatino	R	o	S	a
Garamond	R	o	S	a

65 THE SPACES BETWEEN

One of the most critical aspects of good typography has nothing to do with letterforms, but rather with the spaces between letters. Good letterspacing is what gives logos and headlines a pleasing look of unity and balance.

Clumsy or inconsistent letterspacing, on the other hand, are surefire ways of undermining the aesthetic qualities of any logo or headline you create—no matter how well structured, colored, or crafted any of its other visual elements may be.

Never take your computer's default letterspacing for granted. Question everything—especially if you're establishing the look of featured type, as in the cases of logos and headlines. Sit back and evaluate the appearance of your on-screen words and ask the right side of your brain a few questions about what you see: *Is there a consistent look of evenness among the letters I'm dealing with here? Do the spaces between each of my letters appear similar? Are there congested areas where letters seem too closely spaced? Are there places where letters seem too far apart?*

Try squinting your eyes at your on-screen word(s) as you evaluate letterspacing: Squint until your word(s) appear as something like a gray blur, and then look for areas of darkness that may indicate letters that are too close to each other, as well as for especially light areas that may be the result of overly-large gaps between characters.

Also, look at every possible pair and trio of letters within your logo or headline, and visually assess whether the letterspacing within these pairs and trios comes across as being similar to every other. Use your computer's kerning and letter-spacing controls to make fixes as needed, and, if necessary and practical, convert your letters to paths so you can freely move— and possibly modify—the letterforms of your logo or headline so that its typographic characters can fit together with visually consistent spaces between them.

156

LAVENDER

Default letterspacing. Note the inconsistent visual spaces that occur between the word's first three letters.

LAVENDER

Corrected and tightened letterspacing. The lower bar of the L has been shortened to allow it to sit close to the A.

The (optional) insertion of a graphic element between the L and the A has helped reduce the look of excess space between these letters.

66 TYPOGRAPHIC HIERARCHY

A layout's headline will nearly always be given precedence in the visual pecking order of its typographic elements. This is true whether or not the headline is also given compositional priority over things like images and decorative elements. Subheads are usually assigned a secondary visual role among a layout's typographic components, and text and captions are generally presented with an emphasis on clarity and function rather than on generating notice. (The only real exceptions to axioms like these occur when a layout is being constructed in an intentionally rule-bending way for out-of-the ordinary conceptual or aesthetic purposes.)

Finding the perfect sense of visual hierarchy between a layout's typographic elements often involves playing a kind of tug-of-war between aesthetic goals and practical matters like keeping words large enough to be legible and making sure everything fits comfortably within a layout's parameters.

There are many different ways of affecting the visual pull generated by a layout's typographic components. Say, for instance, you want to increase the amount of attention being generated by an ad's headline, but you're limited in terms of the horizontal space the headline can occupy. You could kern the headline as tightly as possible so that its height could increase, try out a bolder typeface, use a condensed font (one that will allow for a larger type size without overextending the headline horizontally), and/or present the headline in an eye-catching color. You could also lessen the headline's visual impact by applying visual treatments that are the opposite of those just mentioned.

The overall visual impact of a block of text should also be considered when assessing a layout's feeling of hierarchy and balance. If possible, explore different weights for your layout's text, and also compare the look of your text when it is set in different sizes and with different amounts of leading. Slight adjustments to letterspacing can affect the feeling of mass conveyed by a layout's text as well.

Headline

SUBHEAD SUBHEAD SUBHEAD

Lorem ipsum dolor sit amet, consectetur adipisicing elit, sed do eiusmod tempor incididunt ut labore et dolore magna aliqua. Ut enim ad minim veniam, quis nostrud exercitation ullamco laboris nisi ut aliquip ex ea commodo consequat. Duis aute irure dolor in reprehenderit in voluptate velit esse cillum dolore eu fugiat nulla pariatur. Excepteur sint occaecat cupidatat non proident, sunt in culpa qui officia deserunt mollit anim id est laborum. Lorem ipsum dolor sit amet, consectetur adipisicing elit, sed do eiusmod tempor incididunt ut labore et dolore magna aliqua. Ut enim ad minim veniam, quis nostrud exercitation ullamco laboris nisi ut aliquip ex ea commodo consequat.

LOGO

Headline

SUBHEAD SUBHEAD SUBHEAD

Lorem ipsum dolor sit amet, consectetur adipisicing elit, sed do eiusmod tempor incididunt ut labore et dolore magna aliqua. Ut enim ad minim veniam, quis nostrud exercitation ullamco laboris nisi ut aliquip ex ea commodo consequat. Duis aute irure dolor in reprehenderit in voluptate velit esse cillum dolore eu fugiat nulla pariatur. Excepteur sint occaecat cupidatat non proident, sunt in culpa qui officia deserunt mollit anim id est laborum. Lorem ipsum dolor sit amet, consectetur adipisicing elit, sed do eiusmod tempor incididunt ut labore et dolore magna aliqua. Ut enim ad minim veniam, quis nostrud exercitation ullamco laboris nisi ut aliquip ex ea commodo consequat.

LOGO

One ad, four compositional solutions that involve different conveyances of visual hierarchy among the layout's typographic elements.

HEADLINE

SUBHEAD SUBHEAD SUBHEAD

Lorem ipsum dolor sit amet, consectetur adipisicing elit, sed do eiusmod tempor incididunt ut labore et dolore magna aliqua. Ut enim ad minim veniam, quis nostrud exercitation ullamco laboris nisi ut aliquip ex ea commodo consequat. Duis aute irure dolor in reprehenderit in voluptate velit esse cillum dolore eu fugiat nulla pariatur. Excepteur sint occaecat cupidatat non proident, sunt in culpa qui officia deserunt mollit anim id est laborum. Lorem ipsum dolor sit amet, consectetur adipisicing elit, sed do eiusmod tempor incididunt ut labore et dolore magna aliqua. Ut enim ad minim veniam, quis nostrud exercitation ullamco laboris nisi ut aliquip ev consequat.

LOGO

Headline

SUBHEAD SUBHEAD SUBHEAD

Lorem ipsum dolor sit amet, consectetur adipisicing elit, sed do eiusmod tempor incididunt ut labore et dolore magna aliqua. Ut enim ad minim veniam, quis nostrud exercitation ullamco laboris nisi ut aliquip ex ea commodo consequat. Duis aute irure dolor in reprehenderit in voluptate velit esse cillum dolore eu fugiat nulla pariatur. Excepteur sint occaecat cupidatat non proident, sunt in culpa qui officia deserunt mollit anim id est laborum. Lorem ipsum dolor sit amet, consectetur adipisicing elit, sed do eiusmod tempor incididunt ut labore et dolore magna aliqua. Ut enim ad minim veniam, quis nostrud exercitation ullamco laboris nisi ut aliquip ex ea commodo consequat. Duis aute irure dolor in reprehenderit in voluptate velit esse cillum dolore eu fugiat nulla pariatur. Excepteur sint occaecat cupidatat non proident, sunt in culpa qui officia deserunt mollit anim id est laborum. Lorem ipsum dolor sit amet, consectetur adipisicing elit, sed do eiusmod tempor incididunt ut labore et dolore magna aliqua. Ut enim ad minim veniam, quis nostrud

67 TYPOGRAPHIC CUSTOMIZATION

Being able to modify typographic characters in intriguing ways is essential know-how for designers who regularly work on logos and custom headlines—projects that very often call for either subtle or extreme modifications to existing letterforms.

Fortunately, software has gifted modern-day designers with the means of customizing the appearance of letters and words with unprecedented ease and speed.

Illustrator, for instance, provides an ideal environment for modifying the look of typographic characters: Letters can be outlined (or *converted to paths*, as it is often called)—a process that then allows the program to treat letterforms as fully editable shapes. Once characters have been made editable in this way, you can then alter them to include decorative features;

reshape them to take on completely different looks; cut, slice, or otherwise modify them so they fit neatly together with other nearby letterforms; or apply form-altering special effects.

And speaking of typeface customization—and in the interest of taking things a step further—keep your eyes and mind open for opportunities to create fully custom-made characters for any headline or logo you work on. The letters you create could be made entirely from scratch, or they could begin as members of an existing font before receiving their visual and thematic makeover in a program like Illustrator. Look for examples of great designers' typographic creations, and use these samples for ideas, inspiration, and education.

68 ASSENT, DISSENT

Do you want your typeface to bolster themes being expressed by your layout's other compositional components (images, decor, and the like)?

Or would you prefer to make use of type that either playfully or subversively counters the thematic goals being set by the rest of your layout's elements?

There's a time and a place for both of these approaches. Which seems appropriate for the project you're working on? What advice is your creative instinct giving you? Not exactly sure? Use the computer to explore alternatives: Chances are, a favored look will reveal itself before too long—and don't be surprised if the winning solution is one that you weren't necessary expecting when you first began investigating options.

CHAPTER 10

Infusing with Intangibles

69 THE IMPORTANCE OF THEME

First of all, just to be clear, a *theme*—as it's being discussed here—is a quality, a feeling, a purpose, or an idea that pervades a layout, a logo, an illustration, or a photograph. Virtually all notable works of design and art are built around a theme of some kind or another. A theme can be subtle and pedestrian, or it can be audacious and moving—it all depends on the message you're aiming for.

Effective works of design and art usually convey their thematic inferences through visual elements that share like-minded aesthetic and conceptual personalities.

Sometimes, however, it's the associations between dissimilar visual elements that do a piece's theme-generating work—as when, for example, a photograph's lovely content is overlaid with a crudely rendered, graffiti-like headline to convey notions of rebellion or satire.

A theme can be expressed using abstract nouns like *elegance, rebellion,* or *simplicity*. A theme can also be described using adjectives like s*tately, somber,* or *uplifting*. And sometimes a designer or an illustrator might choose to describe the theme of their layout or illustration in terms of a brief statement of purpose, like, *Every component of this piece is aiming toward expressions of grace and efficiency.*

But no matter what word(s) you use to describe the theme of your layout or illustration, know that these word(s) might fall short in terms of fully capturing the expression you want to convey through your work of design or art. That's okay. After all, themes themselves are often at least slightly beyond words—and that's where your creation's content and presentation can enter the equation to deliver difficult-to-express notions, ideas, and feelings through the eyes and into the comprehending brains of viewers.

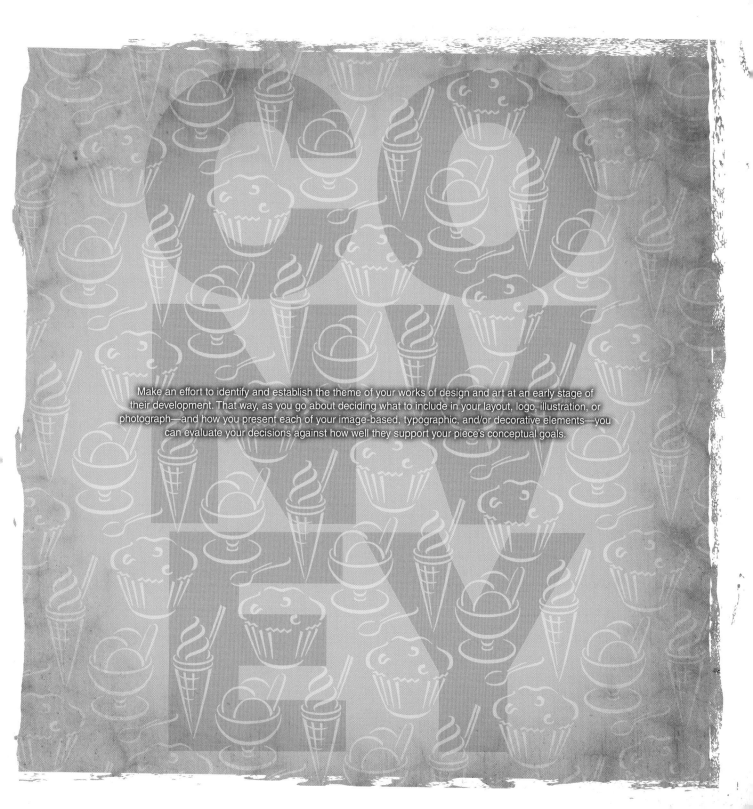

Make an effort to identify and establish the theme of your works of design and art at an early stage of their development. That way, as you go about deciding what to include in your layout, logo, illustration, or photograph—and how you present each of your image-based, typographic, and/or decorative elements—you can evaluate your decisions against how well they support your piece's conceptual goals.

70 CONTROLLING CONVEYANCES

Because layouts usually include a wide variety of theme-generating elements (photos, graphics, headlines, typefaces, decorations, color, and possibly more), they present an especially wide range of opportunities when it comes to the delivery of conceptual conveyances.

Thus, as you work on layouts, be mindful of the many ways in which your piece's thematic projections can be altered by making adjustments to one, some, or all of your piece's components in terms of their style, size, position, and/or color.

Try thinking of each component of your design as being connected to a control unit that can either strengthen or lessen the impact of the thematic inferences being generated by that element.

Working with this virtual control unit in mind, take the time to explore extremes in how its imaginary settings might be applied to your composition's stylistic presentation, compositional structure, and use of color before deciding what works best.

If, for example, you are working on a design that's meant to come across as moderately extroverted, try pushing the look of your layout to the point where it starts to go a bit overboard: Amplify its stylistic conveyances by plugging in typefaces with especially exuberant personalities, exaggerate the size of the piece's headline and/or images, and brighten the layout's colors—all while maintaining strong feelings of aesthetic quality and thematic focus. And then, just when your layout starts coming across as being a little too lively for your liking, begin pulling back on the expressive qualities of some or all of its components until the design starts to convey itself too passively (all the while maintaining aesthetic quality and thematic focus). From that point, it should just be a matter of seeking the perfect middle ground between the two thematic extremes you just explored in order to come up with a look that feels just right.

71 JUXTAPOSITION

What is juxtaposition? It's when two or more things that aren't normally seen with each other are placed together to generate thematic conveyances like weirdness, humor, mystery, cynicism, or social commentary.

When done well, juxtaposition comes across as innovative, eye-catching, clever, and memorable.

Juxtaposition is generally most appropriate when it's used to deliver offbeat, irreverent, or challenging ideas to people who are open to ironic, out-of-the-ordinary, and/or outlandish visuals.

An important thing to remember when employing juxtaposition toward a particular thematic goal is that, even though juxtaposition relies on contextual and conceptual *disagreement* to manifest itself, it should still be aimed in *agreement* with whatever thematic effects you're shooting for with your layout or illustration. Conceptual disagreement and conceptual agreement—in spite of their directly opposing natures—can both be means of arriving at certain thematic targets (just as two roads that seem to be headed in opposite directions sometimes can end up at the same place).

So how about it? Would a juxtaposition of styles, words, images, graphics, or decorative imagery deliver just the right message for the layout, logo, or illustration you're working on? If so, brainstorm both content and stylistic possibilities thoroughly (word list explorations, as described on page 176, would be ideal for this kind of conceptual exploration).

solar

72 EVALUATING AUDIENCE

This, believe it or not, might be the most important spread in *Visual Design,* especially if you're one of those designers (or clients, for that matter) who could use reminding of this oft-forgotten—though extremely critical—fact: *It means nothing if your layout, logo, illustration, or photograph appeals to you if it does not attract, engage, and persuade your piece's target audience.* That's right, in the world of commercial art, any work of design, art, or photography cannot be right if its target audience thinks it's wrong.

The lesson? Get to know your target audience, and keep their aesthetic and thematic preferences at the fore of your mind as you work.

Start by finding out whom your target audience is. Your client should be able to help you with this (and if they aren't sure exactly who they are trying to reach with their product or message, they would probably do well to find out—perhaps with the help of a savvy marketing strategist).

Once you've identified your piece's target audience, take the time to investigate the media—the magazines, videos, books, websites, and more—that these people look at. Look at this media as a way of clarifying your understanding of your audience's tastes regarding their preferences in colors, subject matter, typefaces, and stylistic presentations. Also, if there is time and budget, consider setting up an opportunity to talk with a small cross-section of the audience you'll be targeting. You might be amazed at the insights that can be gained through face-to-face interaction with the people you will be trying to attract, engage, and persuade through your work.

Doing this may not feel much like design or creativity, but it is important. Very important. And, done well, it will help ensure that the creative work you're about to undertake will have a significantly improved chance of successfully communicating your client's message to the demographic with whom they are trying to connect.

73 ASSESSING COMPETITION

It's risky to begin any design project without gaining a strong understanding of your target audience: Projects that are begun without a clear picture of the tastes of the people you will be trying to impress and engage stand a good chance of turning into a heartbreaking waste of time and energy for both designer and client.

174 It's also risky—and inadvisable—to dive into any design or illustration project without taking a good look at potentially competing material that is already in print or posted online—media that your target audience is probably already familiar with. Without an awareness of what's been done, it becomes difficult or impossible to know whether or not the visuals you're about to create will stand out from the crowd, or—even worse—that they might be perceived as copy-cat or plagiarized versions of material that's already in circulation.

Either of these scenarios could spell disaster for the designer (you, in other words) and your client, and also for your designer/client relations—and thus are situations that are clearly best avoided.

The good news in all this is that it's easier than ever to survey existing works of design and illustration before beginning projects of your own. Start by asking your client about who their competitors are, and then go online and see what you can find in the way of material that may in any way compete with—or be compared to—the piece(s) you're working on. Thirty minutes or an hour may be all that's needed to search the Web for examples of logos, websites, photos, illustrations, brochures, posters, and packaging that may be helpful in steering the look of whatever it is you'll be creating toward fresh and uncrowded creative territory.

74 BRAINSTORMING

You've met with the client, been informed about the project at hand, learned what you need to know about your target audience, and have taken a look at potentially competing works.

Now it's time to get the ideas flowing. Here's a tip to get this process off to a strong and productive start: Begin with words. Why words? Words are easy to conjure and quick to record, and when they are received in the synapses of creative minds, they very often explode into fireworks of imagery and ideas.

Start by writing or typing nouns related to the subject matter you will be dealing with for the logo, layout, or illustration you're working on—any physical or abstract thing that might have even a tiny chance of making it into your final design. Also make lists of descriptors that connect with the thematic conveyances you're seeking through your project (see The Importance of Theme, page 166) and, in general, record absolutely *any* potentially relevant word or sentence that comes to mind (brainstorm!). Use the Web and a thesaurus to

help fill your sheet(s) of paper with as much material possible.

Next, look at everything you've written down and let each word and sentence resonate, one by one, in your creative and resourceful brain. Chances are, several items will lead to a quick thumbnail sketch or a written reminder of an idea worth considering.

After that, look at pairs and trios of words that are more or less randomly selected from around your page(s). Balloons plus birds, for example, or bees plus automobiles, or head plus lightbulb plus sparkles.

Intriguing and exciting imagery is almost bound to spring to mind as you ponder these associations. Make quick thumbnail sketches of any and all potentially useful ideas that arise (no concept is insignificant at this stage—it's amazing how often a half-formed and seemingly inert thumbnail sketch can suddenly snowball into a stream of better, more complete and increasingly exhilarating ideas).

75 BANKING IDEAS

A small amount of stress—or, at the very least, an ambient sense of urgency—can help bring a sense of focus and purpose to the creative process.

Large-scale stress, on the other hand, is usually something to be avoided since—for most of us, anyway—an overabundance of pressure tends to create a downward spiral where creative thinking diminishes at about the same rate as feelings of panic arise.

178

Here's a technique you can use to help minimize stress—and simultaneously maximize creative output—when conducting something along the lines of the brainstorming/thumbnailing practice described on the previous spread. It's called *banking ideas* and it goes like this: Every so often, as you work, sit back and evaluate your thumbnails, and circle those that seem to have potential as winning ideas. Circle the sketches, consider them safely stored in your savings bank of ideas, and continue brainstorming/thumbnailing additional material.

Once you've banked at least a small handful of reassuringly promising sketches, you'll notice that any anxieties you might have felt earlier about being able to come up with strong concepts and visuals will begin to fade in the knowledge that you've got a growing set of worthy material already safely penned and stored. The knowledge that you have these viable ideas-in-waiting can—and most often will—provide you with just the mental breathing space you need to come up with even better ideas: concepts that can take the place of those already held in your virtual bank of safekeeping.

Give it a try sometime. The worst thing that might happen is that you end up with so many promising sketches that you'll find it challenging to narrow them down into the three or four you want to develop for presentation. Not such a bad—or stress-inducing—problem to have, wouldn't you say?

76 QUESTION EVERYTHING

It's time to evaluate. You're not quite ready to show the client what you've been up to, but you're sitting in front of your monitor (or a set of printouts) and you're looking at the logo, layout, illustration, or website that represents your best efforts as a creative professional. And, yes, you're happy with what you see in terms both surface-level aesthetics and down-deep thematic conveyances.

What now? *Question everything.*

That's right: Refrain from patting yourself on the back momentarily, call upon the analytical and dispassionate recesses of your brain, and take a cold, hard look at the position, size, color, and stylistic aspects of every element of your creation. In fact, go ahead and take on the mindset of a tough-minded member of your target audience and second-guess every typographic, textual, photographic, illustrative, decorative, and conceptual choice that's gone into your work of design or art—whether it applies to a starring, supporting, or background component of your piece.

If text is involved, proof and reproof every line. And pay special attention to headlines and subheads: It's uncanny how easy it is to overlook typos among a piece's most prominent textual elements.

Visually and mentally cross-examine every aspect of every work of design and art you create prior to presentation, and, if and when you spot something that isn't quite right, be fully prepared and willing to take whatever steps are necessary to bring the piece as near to perfection as possible before handing it over for review.

Among its many other benefits, this is a practice that will go a long way toward establishing amicable and long-lasting relations between you and your clientele. Clients love on-the-ball designers and artists who have a sharp eye for detail and a proclivity for consistently delivering work that is as mistake-free as humanly possible.

Image: Larger? Smaller? More color? Different style?

Headline: Bolder? Higher? Lower? Wider?

Text: Proofed? Correct kerning and leading? Correct point size?

Border: Less bold? More colorful? Needed at all?

Colors: Brighter? More muted? Less varied?

CHAPTER 11

Avoiding Unsightliness

77 DECIDE

Be decisive, always, when creating layouts, logos, and illustrations. Determine your piece's compositional structure, colors, imagery, decor, typographic presentation, and stylistic flavor based on your well-considered thematic and aesthetic goals, and then take full and confident measures to reach what you're aiming for.

A lack of decisiveness when developing and finalizing works of design and art can lead squarely to precise, wholehearted, uncompromising, and unambiguous looks of imprecision, halfheartedness, compromise, and ambiguity. Bad things, each.

Indecision, in other words, can kill works of design and art, or, at the very least, drain them of vitality and their ability to communicate with clarity and resolve.

Here are a few examples of indecision manifesting itself through layouts and illustrations: Uncertain attempts at visual structure that come across as neither purposely orderly or intentionally disorderly; indefinite typographic choices like the use of a mid-weight typeface for a headline that would be better served by a font that is either authoritatively bold or elegantly light; vague endeavors to inject notes of excitement into a composition—like a headline that is tilted just enough to make a viewer wonder if the type's skewed placement was accidental or intentional; and tepid palette-building approaches that result in color schemes that displease few, but thrill even fewer.

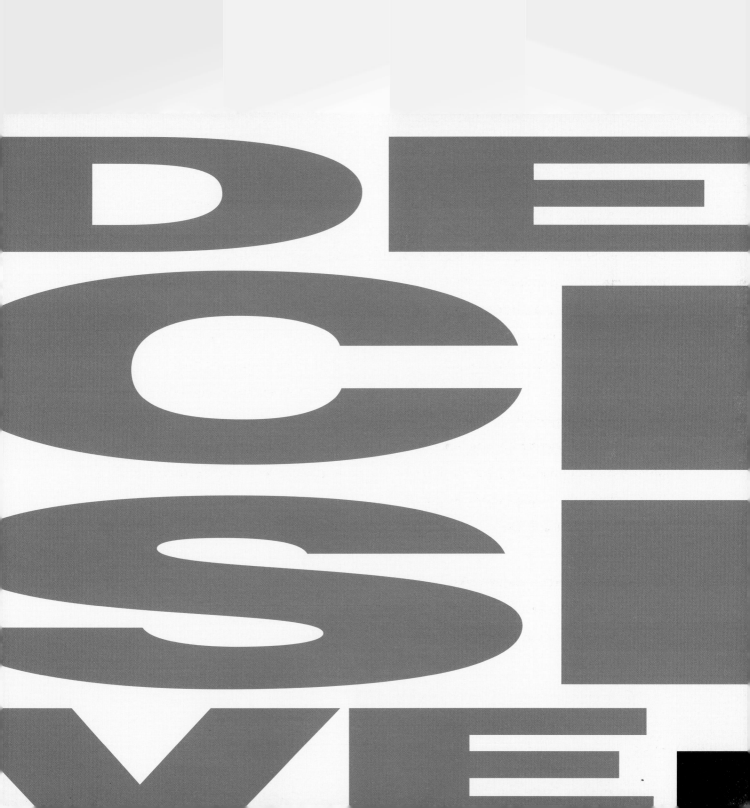

78 BE AWARE

A layout or an illustration whose aesthetic and conceptual qualities are perfectly right can still fail if they are simply in the wrong place at the wrong time. This phenomenon is known as being out of style. And works of design and art that are out of style are very easily dismissed by viewers as being irrelevant, awkward, and unsightly.

It's essential, then, to pay close attention to what's happening in today's popular culture—particularly as it applies to advertising, design, illustration, and photography. Design and illustration periodicals (both printed and Web-posted), as mentioned throughout this book, are excellent sources of up-to-date work created by leaders in the creative arts.

Cultivate the habit of regularly looking at these kinds of media, as well as the practice of taking note of current examples of industrial design, interior design, fine art, clothing, autos, and architecture. The more you're able to load your eyes and brain with contemporary and varied expressions of design and art, the better you'll be able to assess how well your own creations fit within the spectrum of present-day stylistic parameters.

When looking at outstanding examples of today's commercial art, do your best to analyze the typefaces, colors, styles, and compositional structures that make these pieces the effective and timely conveyors of expression and information they are. And even if you feel overwhelmed by what you see, can't name every typeface you come across, or don't understand the thinking behind every palette you catch sight of, just know that the act of looking—all by itself—will allow your brain to absorb extremely useful visual and stylistic cues that will assist you in keeping your work in step with contemporary tastes.

79 ESTABLISH PECKING ORDER

You know you are looking at a layout with a clear sense of visual hierarchy (page 50) when your eye is being given unmistakable cues as to where to enter a composition, where to go after that, and after that, and so on.

And when this visual pecking order fails, layouts suffer—as do the viewers of these pieces who find themselves confused by, not attracted to, or frustrated with a layout's message and its thematic thrust.

How common are layouts that fail in terms of visual hierarchy? Very common, unfortunately. In fact, one of the most frequent causes of unsightliness in layouts that have been created by both novice and experienced designers is a misapplication—or a complete absence—of visual hierarchy among their compositions' elements.

The main thing about establishing a layout's pecking order is that you don't chicken out. Boldly make whatever decisions are necessary to establish a clear sense of visual hierarchy among your composition's components. Sometimes this means emphasizing the presence of certain items by virtue of their size, color, boldness, and/or placement, and other times it means reducing the visual impact of elements that—in spite of their importance (your client's logo, for example)— ought not compromise the aesthetic integrity of the layout of which they are a part by calling too much attention to themselves.

So do it, always: Decide which of your composition's elements need top billing in the layout or illustration you're working on, which elements deserve less notice, and which are to be treated as peripheral and background components. And then, make it happen.

80 VALUE VALUES

Poor value structure is a leading cause of under-achievement among illustrations and photographs that fail to present themselves with clarity, confidence, and beauty.

Good value structure (discussed on page 122) is an arrangement of dark, mid-tone, and light shades of color that allow an image's elements to stand out clearly against each other. Poor value structure hurts illustrations and photographs by hiding distinctions between their visual components and, therefore, by obscuring whatever aesthetic and thematic goals the images are aiming for.

Values, of course, are also critical to ensuring the effective presentation of layouts and logos. In fact, any form of art that presents itself through either shades of gray or palettes of color (design, illustration, fine art, photography, interior decoration, and fashion design included) depend on strong value structures in order

to appeal to the eyes—and to communicate with the minds—of viewers.

Simple enough, right? Yes… but still not always easy to accomplish. Designers and illustrators who are fighting the good fight for effective value structure often have to struggle mightily with what feels like an overwhelming visual puzzle where just about every attempt to help one color stand out seems to cause others to disappear into near obscurity. That said, know that there are always remedies to problematic value structure issues, and that you should never give up on finding these sometimes difficult-to-reach solutions. This may mean adding to, taking away from, altering, or replacing hues within a palette; incorporating linework in your layout or illustration to help establish boundaries between colors whose values are fighting; and/or resizing or repositioning elements within a composition so that problematic collisions between hues of similar value are avoided.

81 MIND TANGENTS

Here's another thing to watch out for whenever you compose a layout, design a logo, create a graphic, render an illustration, or shoot a photograph (pretty much any time you're creating any piece of design or imagery, in other words): *hurtful tangents.*

For starters, then, what is a tangent? In the language of design and art, a tangent is the very point at which any two shapes are (or are very nearly) meeting, touching, tapping, patting, grazing, or kissing one another—without crossing or overlapping.

To appreciate how tangents can hurt, you need to understand how they interact with the eye. You see, eyes are consciously—and unconsciously—pulled toward tangents for the very same reason they are drawn to things like a pair of glasses that are sitting precariously close to the edge of a countertop, or to the sight of someone's bare feet standing dangerously near a thumbtack. The eye simply wants to know what's about to happen: Are the eyeglasses going to fall? Are the feet going to step on the tack? Are the shapes going to meet, touch, tap, pat, graze, or kiss? Or are they not?!

Granted, this description of the effects of visual tangents is not quite scientific, but it is an adequately (and hopefully easy-to-remember) account of the visual magnetism—and the sense of discomfort—that arises when tangents appear between two compositional elements of a pattern, between a photograph's subject and its horizon line, between the letters of a headline, or between any visual component that is part of any kind of compositional arrangement.

Take care, then, to avoid hurtful tangents when composing works of design or art (unless, that is, you're actively aiming for subtle or overt feelings of distress, unease, or aggravation—in which case, a few hurtful tangents might be perfectly acceptable).

82 SEE WITH FRESH EYES

Evaluating our own layouts, logos, illustrations, and photographs is tough. Anyone who creates works of design or art knows about being too close, too involved, and too familiar with their creations in order to see them with unbiased eyes.

So how should we go about self-assessing the look, style, and content of our creations? How can we help ourselves watch out for the unsightliness-causing issues talked about throughout this chapter?

To begin with, we can step back. Literally. It's amazing how differently we see things when we are looking at them from a distance that's greater than our usual eyeball-to-monitor span. Go ahead, roll your chair back a few feet and see how your work of design or art looks from there. Or, perhaps better yet—and especially if you're working on something like a logo that's meant to be viewed at different sizes and from varied distances—print your document, stick it up on a wall, and see how it looks from across the room.

You might be surprised at how readily compositional weaknesses (and strengths, for that matter) reveal themselves when viewed from afar.

Also, try flipping your layout or image horizontally and/or vertically on your computer screen (or printing it out as a flipped version of itself) and looking at it in this way. This is a great trick for helping your brain assess a familiar piece of art as though it were seeing something new.

And lastly, if you are able to get ahead of your deadline by a couple days or more, know that there are few better ways of figuratively—and literally—distancing yourself from the piece of design or art you've been working on than by walking away from it for anywhere from a couple days to a couple weeks. Just keep the thing out of sight for as long as you reasonably can and then, when you're ready, view and critique it with eyes that likely will feel noticeably fresher and less biased than before.

196 | CHAPTER 12

Practical Matters

When a designer produces a color layout or illustration that's destined for print, chances are good that the piece will be printed by either an offset printing press or a digital inkjet printer.* Printing of either kind usually involves cyan, magenta, yellow, and black inks. These four inks are referred to as CMYK colors (the letter K is used to represent black since the black plate in offset printing is sometimes referred to as the key plate).

The density of each of these colors can be varied by printing the inks as very small repetitions of dots known as *screens* or *halftone patterns*. The density at which inks can be printed can range anywhere from a 1% concentration to a solid layer of ink. All the colors we see in layouts, illustrations, and photographs that have been printed using CMYK inks are made by overlapping specific densities of one, two, three, or all four of these colors of ink.

If you are a graphic artist and you create layouts and illustrations that are destined for color printing, then you must learn the ways of CMYK, offset printing (also referred to as *process-color printing*, and simply as *process printing*), and digital inkjet printing. A solid understanding of these aspects of the color printing world will go a long way in helping you prepare your electronic documents for ink-on-paper output with as much accuracy and as few mistakes as possible.

This chapter can touch on only surface-level topics of color output, since printing, itself, is a subject worthy of a full book (and possibly an entire shelf of books). If you're new to color printing, begin building your knowledge now by talking with printers and designers about the things you need to know, and also by consulting books and websites for information when needed. Time and experience will take care of the rest.

*Print jobs of higher quantities are usually printed using traditional offset printing presses. Shorter print runs are often handled with inkjet printers. See page 206 for more about inkjet printing.

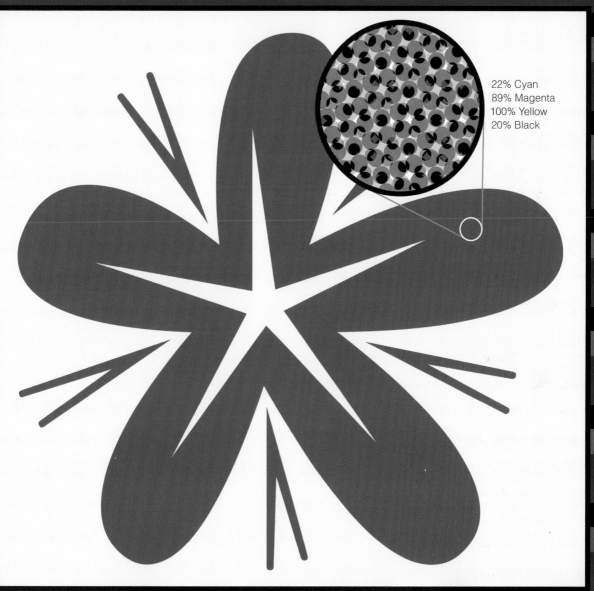

22% Cyan
89% Magenta
100% Yellow
20% Black

CMYK

84 PROCESS PRINTING KNOW-HOW

Here are a few good-to-know facts and cautions related to color printing—things to bear in mind when designing and producing layouts and illustrations that are destined to be printed on either an offset press or an inkjet printer.

[A] DPI means dots per inch—as in, how many halftone dots appear, per inch, on a printed page. 300 DPI is the standard resolution for printing (72 DPI is the usual standard for on-screen material). Make sure your for-print images and documents have been set up at 300 DPI so they'll print with maximum clarity and quality. If you're not familiar with how to establish the DPI for your documents, or how DPI affects photographs and illustrations, consult your software's user manuals and/or seek printed or online information on this matter. It's important.

[B] Be perpetually aware that the colors you see on your computer monitor will look different when printed. Use something like a printed process color guide (a book that shows many thousands of CMYK color swatches) or a spot color guide (mentioned in [D]) to get a clearer idea of how the colors you apply to digital documents will actually look when printed. (See page 208 for more about this.)

[C] When screen-builds of two or more solid or halftoned CMYK inks are printed on top of each other, a specific color is produced. On a related and cautionary note, be careful not to apply complex screen-builds to extremely thin linework or fine type: Your press operator will have a very hard time keeping all the tiny halftone dots of color properly aligned within the narrow spaces of these graphic elements, and the results will likely be disappointing. Same goes for reversing* linework or

type from screen-builds: don't go too thin with your lines or letters because even a fractional misalignment between a screen-build's inks can cause thin reversed areas to fill with ink.

[D] Spot colors are different from CMYK colors in that spot colors are formulated as ready-to-go cans of ink that are mixed prior to being added to printing presses (as opposed to process colors that are created when CMYK inks are overlaid on paper, as shown in [C]). Spot colors are usually selected from printed guides offered by companies such as Pantone. Designers often choose to use spot colors for economical reasons. For example, if a brochure calls for only black plus a client's red-orange corporate color, then it would probably be cheaper to run the brochure as a two-color job (black plus the spot color) than it would be to print the job using the four inks of CMYK printing.

[E] Very importantly, consult with your printer if you have questions about properly preparing your job for process-color printing. Most printing companies will gladly put you in touch with someone who can answer your questions since, really, it's in the printer's best interests to receive properly set-up documents for the work they'll be doing for you.

[F] Your printing company will provide you with a prepress proof before your color job is printed. Take this proof seriously. Carefully inspect every detail of the proof, including, of course, its colors. If something doesn't look right with the proof, it either has to do with the way your document was set up or the way the printing company used your document. If the fault is yours, then you'll need to make adjustments to your digital file (and possibly incur additional charges) and look at another proof.

*A reminder to consult the glossary if you are unfamiliar with any of the terms presented in this chapter.

300DPI

A

≠

B

C

22% CYAN

89% MAGENTA

100% YELLOW

20% BLACK

22C, 89M, 100Y, 20K

D

QUESTION

ANSWER

[YOU] [PRINTER]

E

F

PROOF

85 PAPER

The right or wrong paper (or *stock*) can make or break the presentation of any business card, letterhead, brochure, poster, or newsletter you design. Most paper and printing companies will go out of their way to help designers choose the right paper for their print jobs. Take advantage of any advice and tips you can get from paper and printing representatives about the pros, cons, and potential pitfalls of various paper choices.

Also, expand your knowledge of commercial printing papers by talking with experienced designers. Most designers who work with print media have strong preferences and favorites in terms of the papers they use for their projects.

An almost endless variety of white, colored, speckled, fibrous, and parchment-like stocks are available these days. Paper can have a gloss (coated), matte (uncoated), satin, felt, smooth, textured, dimpled, or ridged finish. Many stocks are available in weights ranging from typical letterhead thicknesses to that used for heavy-duty business cards, and the variety of pre- and post-consumer recycled options is growing all the time.

Glossy coated stocks—because they absorb less ink into their fibers than other papers— are able to present color images with greater clarity and crispness than uncoated stocks. Uncoated papers should not be ruled out, however, when printing in color: Sometimes the slightly softened look of text and images on uncoated stocks is just what's needed for a piece's sought-after look and its tactile feel.

Be mindful of the fact that inks are semitransparent when printing on a stock that's anything but white: A paper's color will affect the look of any inks that are printed on top of it. The effect a lightly colored stock will have on ink color is usually minimal or negligible, but if you're planning to print on a stock with a noticeable shade of color, then talk with your printer to find out what adjustments might need to be made to your document's colors in order for it to print properly.

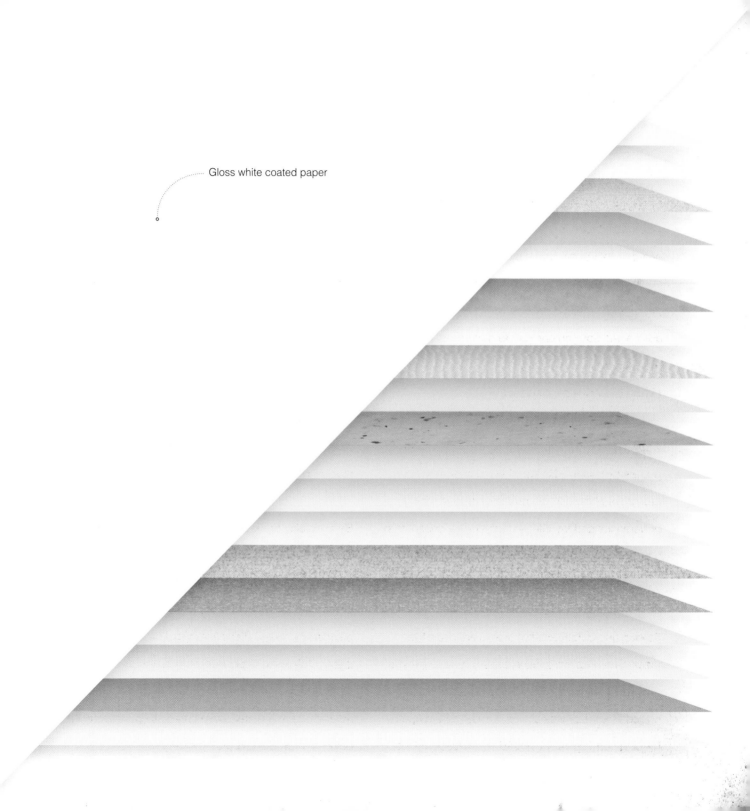

Gloss white coated paper

86 PRESS CHECKS

This page deals with quality-control issues involving offset printing presses. The next spread concerns itself with similar issues as they pertain to digital inkjet systems.

What's a press check? This is where you look at samples of your printed piece as they come off the press, and where you inspect your job for quality and for color accuracy. A press check is your final opportunity to make sure the work of design that you've been involved with for the past days, weeks, or months ends up looking as good as it possibly can.

At a press check, you'll mainly be comparing freshly printed sheets of paper with the printer-supplied proof (usually inkjet printed) that you have already approved. One thing you must understand when doing this is that it's extremely unlikely that the ink-on-paper printed sheets coming off an offset printing press will exactly match the inkjet-printed proof that you're using for reference. That said, learn to work with press operators during press checks to come up with printed pieces whose colors in critical areas (skin-tone regions of photographs, for example, and

areas that contain your client's corporate colors) are as accurate as possible while granting allowance for minor color inaccuracies elsewhere in your design. And always keep in mind that, with offset presses, when you ask a press operator to alter a color in one area of a printed piece, colors in other areas will be affected as well.

Additionally, look carefully at your entire printed piece for general quality-control issues like specks of ink where they don't belong and blemishes within areas of solid ink coverage.

Good press check etiquette includes allowing press operators as much time as they need to dial in the proper settings for your job (printing presses are complicated and—at times—very temperamental machines); paying close attention when a press operator is trying to explain what can—and what probably can't—be done with the colors of your printed piece; and, naturally, being as courteous and as patient as possible when difficulties arise.

☐ Colors accurate and properly aligned?

☐ All photos look good?

☐ Smooth ink coverage throughout?

☐ Any blemishes?

☐ All art elements present and accounted for?

☐ Will the piece fold properly?

☐ Paper is the right stock?

87 DIGITAL PRINTING

Digital printing involving inkjet printers is on the rise. Inkjet printers have come a long way during the past two decades, and are being increasingly used for print jobs that would have been handled exclusively by offset presses in the past. Digital printing is particularly cost-effective when the number of pieces being printed is relatively small (offset printing is still the economical choice for most larger-quantity jobs).

Your printing company will be able to tell you if the job you're working on is best suited for offset printing or for digital reproduction.

Quality control is less complicated when printing digitally than it is when a job is being run on an offset press. This is because the proofs you will be reviewing prior to a digital print-run will have also been printed digitally—and therefore you can expect a much closer match between the proofs you've approved and the final product (an exact match, in fact, is often a real possibility—especially when your job is being run on the very same machine that was used to create the pre-run proof).

If you have a high quality inkjet printer in your office, it's likely that you'll be able to calibrate it so that it very nearly matches the output of your printing company's inkjet machine (see your machine's documentation to find out more about calibration techniques). This would go a long way in helping reduce stress when it comes to preparing artwork that is likely to offer up few—if any—negative surprises when it is handed over to your printing company for output.

88 WYSIWYG?

What you see is what you get: WYSIWYG.

But, is what you see on your monitor really what you'll get when your job comes out of the far end of an offset printing press or a digital printer? That's a tricky question to answer given the large variety of factors involving computers, monitors, overhead lighting, inks, and printing equipment that are inevitably involved.

The most important thing you can do to help ensure that what you see on screen will match how your jobs will look when printed is to use a good-quality monitor and to calibrate it accurately. Monitor calibration techniques vary per monitor, so look into this matter and give it some serious attention—especially if you work much with print media. (Also, be aware that the lighting conditions in your office or studio will affect the way colors appear on your monitor, so make an effort to come up with a consistent and color-balanced lighting solution for your workspace).

Additionally, you may want to purchase a handheld monitor calibration tool that you can use to thoroughly fine-tune your on-screen presentation of color. If you are interested in a tool of this kind, do some online investigation (and also talk with other designers, photographers, and printers, if possible) to find out what the latest, best, and most affordable options are.

89 IS IT SAFE YET?

It's been quite a while since websites needed to be designed around a palette of the 216 *Web-safe* colors—hues that could be presented on early-generation monitors as solid panels of color and without any annoying dithering (tiny halftone-like dots contained within areas of color).

These days, just about everyone who uses a computer also has a monitor that can present millions of colors without the slightest trace of dithering. So, the question is, why do so many designers still adhere to the dogma of the so-called Web-safe palette?

One reason is that the news about the obsolescence of the Web-safe palette just doesn't seem to have reached all designers' ears.

Also, some designers—even among those who are up-to-date in their knowledge of current monitor capabilities—continue to use the Web-safe palette as a matter of point-and-click convenience since programs like Illustrator, Photoshop, and InDesign, as well as countless websites, make these palettes so readily accessible.

There is also a convenience factor when it comes to plugging these colors into HTML and CSS documents, since their color codes are generally simple and easy to remember.

But do you really want to be among those designers who limit themselves to just 216 colors when millions are actually available? Hopefully not.

Advice: Dump this archaic way of thinking and open yourself up to colors that look good, fit the needs of a project, and appeal to the eyes of the target audiences who will be viewing your on-screen works of design and art—and quit worrying about the so-called safety of your on-screen colors, once and for all.

CHAPTER 13

Inspiration and Education

90 LEARN FROM THE GREATS

As commercial artists (designers, illustrators, photographers, et al), our real task is to find ways of delivering messages, information, and ideas through a vocabulary that not only includes words, but also images, typefaces, decor, color, abstract themes, and stylistic inferences.

214

This broad communicative vocabulary, in order to come across as being as worthy of attention as possible, needs to manifest itself through layouts, logos, illustrations, and photographs that are recognized by their target audiences as being timely, relevant, and remarkable within the context of today's media.

A tall order, for sure. So, how do we do it? How do we keep our figurative fingers on the imaginary pulse of the modern-day cultural preferences that affect the audiences we target with our aesthetically attractive work?

For one thing—as mentioned throughout this book—we can do this by keeping our eyes on the works of outstanding contemporary designers, illustrators, artists, photographers, and anyone else involved in the creation of visual art. The leaders in any of these fields tend to be exactly those who have demonstrated the sharpest mastery of the visual vocabulary of their media as well as a consistent ability to effectively convey the aesthetic, stylistic, and thematic qualities of their work within the context of current trends.

91 NOTE, EXAMINE, COMPREHEND

What exactly should you be doing with your eyes and your brain when you look upon superb examples of design? Taking note of, and examining, each of the piece's individual components: its images, typefaces, borders, linework, decorations, coloring, and more.

Also, and importantly, you will be trying to comprehend just how it is the designer of the piece came up with its specific look, feel, and structure so that you might be able to adopt a related mindset—toward similar (but certainly not identical) ends—for projects of your own.

This same level of examination and contemplation can—and should—be applied when viewing inspiring works of illustration, photography, fine art, architecture, and any other form of visual expression that might populate your head with potentially useful ideas, imagery, and themes.

It goes without saying that better designers don't copy directly from any work of design or art. Still, designers of all levels would do well to allow the essence of inspirational visuals to filter through their own internal maze of instinct and intellect en route to sparking unique and fresh creative approaches. This, after all, is how artists of one era or place have always used the material of artists from other eras and places to shape and advance the way they approach and create visuals of their own.

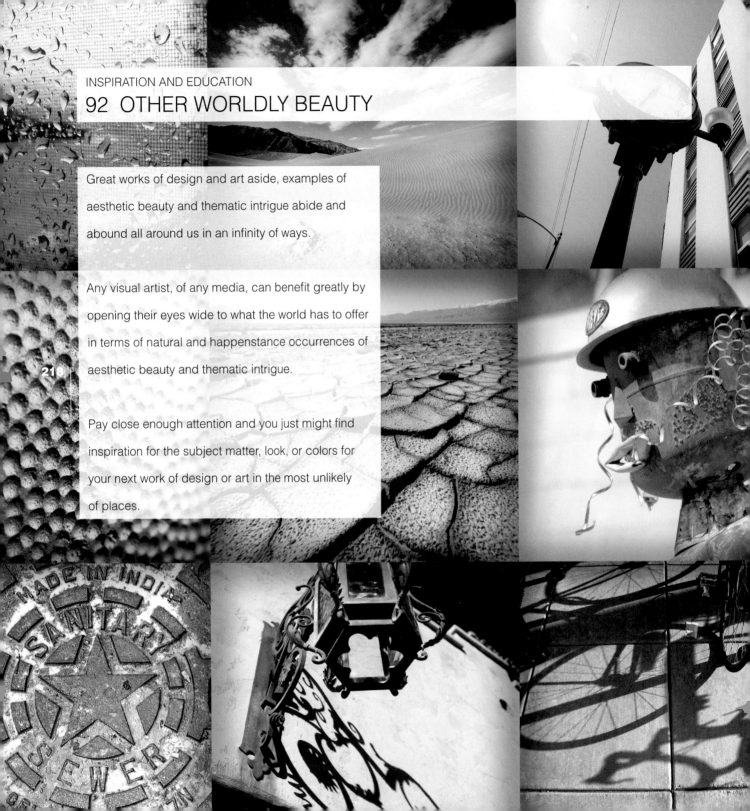

92 OTHER WORLDLY BEAUTY

Great works of design and art aside, examples of aesthetic beauty and thematic intrigue abide and abound all around us in an infinity of ways.

Any visual artist, of any media, can benefit greatly by opening their eyes wide to what the world has to offer in terms of natural and happenstance occurrences of aesthetic beauty and thematic intrigue.

Pay close enough attention and you just might find inspiration for the subject matter, look, or colors for your next work of design or art in the most unlikely of places.

218

93 SAVING VISUALS

Before the days of digital storage systems, many designers kept and maintained a physical *scrap file* of favorite ads, magazine spreads, brochure covers, logos, graphics, illustrations, and photographs. Files containing isolated examples of typographic specimens, decorative elements, and palettes of color were also kept in this way.

Commercial artists would turn to these collections of stored visuals when brainstorming ideas for projects of their own.

Not too many designers maintain extensive files of printed material as sources of inspiration now that the digital caching of imagery has become the norm, but the idea of setting up a system of saving images for future referral and inspection is as relevant and useful today as ever.

How about you? Do you have a digitized storehouse of visuals that exemplify masterful aspects of design and art? A set of files that you can turn to as sources for enlightenment and knowledge? It's easy enough to do. For one thing, you can drag-and-drop images from online sources and add them to your cache, and you can also use your pocket digital camera to snap photos of intriguing works of design and art wherever and whenever you come across them. (Your camera could also be used to collect photos of any sort of inspiring subject matter you come across in daily life—photos such as those shown on the previous spread.) You can easily disperse images collected in this way according to theme and/or content using an image-organizing program such as iPhoto, Aperture, or Lightroom.

94 LEAVE IT ALONE

This book is filled with information and ideas that are meant to expand and sharpen the skills we apply to our professional and personal works of design and art.

Visual Design would never be complete, however, without mention of another particularly important thing you can do to significantly improve your potential of achieving—and exceeding—your creative goals: Leaving it alone.

That's right. Actively seek and protect times when you can shut down your computer, turn off your digital camera, close your sketch pad, ignore any art tools you have lying around your office or home, quiet down your creative impulses, and just… leave it all alone… and do something else.

That something else could be sitting on a park bench and people-watching during lunch. It might involve carving out time for exercise before or after work. It could have something to do with hanging out with friends or family. It might be time spent digging up weeds, writing a letter, flying a kite, reading a book, or playing the banjo. Anything at all—except for any kind of creative project that actively reminds you of your work as a designer, illustrator, photographer, or fine artist.

Not only are activities like these allowed in the life of creative professionals, they are essential to promoting your career through enhanced longevity and growth. How so? First, all work and no play can be endured for a while, but eventually it tends to wear us down to the point where we want to quit and do something else—thus defeating any chance we have of attaining longevity in our career as creative professionals. Second, the things we do apart from our creative professions often provide the very mental-matter we need to fuel our on-the-job creativity: The sights we see, the books we read, the foods we eat, the music we hear, the activities we experience, the conversations we take part in can (and almost invariably will) improve the potency and breadth of our ability to come up with intriguing and attractive content for our works of design or art.

95 EXPAND AND EVOLVE

Times change. Tools change. People change, too, and if you want to keep afloat in the constantly moving currents of style, technology, and culture, you'll need to find ways of perpetually expanding and evolving both your mental and hands-on creative skills.

Your job security, too, may be impacted by your willingness to be mindful of—and engaged with—up-to-date styles and technologies. A sharp and relevant awareness of these matters is a basic component of a creative professional's value to their employer and/or clientele.

As mentioned consistently throughout this book, make a regular point of staying open to forward-thinking ideas and information offered through books, websites, magazines, conferences, professional associations, coworkers, and everyday life.

And don't be afraid to put what you're learning to use even before you're sure that you have a complete grasp on whatever it is you're trying to become proficient in. Hands-on, real-world, deadline-driven experiences seem to accelerate the learning process of most designers and illustrators.

Also, and very importantly, don't put off the things you really want to learn—whether this means expanding your skills of design, illustration, typography, photography, video, fine arts, or any other form of creative expression. Claim whatever small and large chunks of personal time are necessary to learn the new skills and media you're interested in (personal time is usually a prerequisite for the learning of new things, since we are rarely allowed free exploration of new skills and media while on the clock): Jump right in and then proceed with enthusiasm, patience, enjoyment, and purpose.

You are here

Glossary

GLOSSARY

Note: The definitions provided here are given within the sense of how these terms are used within the content of this book.

Annual

A publication centered around topics related to design and art that's issued once per year. Annuals usually feature the work of influential and trendsetting creative professionals.

Blackletter

Fonts that are based on the heavy, angular calligraphic letterforms often seen in manuscripts from the 12th to 17th centuries.

Bleed

To allow areas of a printed piece to be printed slightly beyond the edges of what will be the trimmed size of the sheet of paper (resulting in ink coverage that goes right to the edge of the piece).

Callout

Labels and bits of text—usually small—that are sometimes added to illustrations, schematics, maps, and photographs to point out details and to provide information.

CMYK

An acronym for *cyan, magenta, yellow,* and *black* (the letter K is used to represent black since the black plate in offset printing is sometimes referred to as the key plate).

Color Guide

A panel offered through Illustrator that features dark, light, muted, and brightened versions of specific colors.

Color Picker

A panel offered through Illustrator and Photoshop that can be useful in finding dark, light, muted, and brightened versions of specific hues.

Columns

Areas of a layout that hold text. Columns are usually rectangular and vertically oriented. Layouts often feature between one and five columns of text.

Cool gray

A gray with hints of blue, violet, or green. Also see *Warm gray.*

Cool hue

Colors that tend toward blue, violet, or green. Also see *Warm hue.*

Crop

To eliminate unwanted areas of a photo or an illustration.

Digital printing

Printing that is done using inkjet printers.

Dingbat

A typographic character other than a letter or a numeral. Dingbats can be images, symbols, or decorative items.

DPI

Acronym for *dots per inch*, a measurement used to define the resolution of digital images. More dots per inch generally equate to sharper-looking images.

Dynamic spacing

Varied amounts of spacing between and around the elements of a layout. Also see *Static spacing.*

Eyedropper tool

A tool offered through Illustrator, Photoshop, and InDesign that allows users to select specific colors from photos, illustrations, and graphics—and (if desired) apply them elsewhere.

Font

Traditionally, a word used describe a specific size, style, and weight of a typeface. These days, the word *font* is generally used interchangeably with *typeface.*

Frame

To bracket or otherwise surround a compositional element with other elements of a layout or an image.

Golden ratio

The golden ratio—often represented by the Greek letter phi (Φ)—is a specific ratio of measurements that seem especially pleasing to the eye. To find a measurement's golden ratio companion, multiply the measurement by 1.62.

GLOSSARY

Grid

A set of reference guidelines that can be employed to generate cues for the placement of a layout's components. Grids are used during the development of a layout but are not seen in the final printed or posted piece.

Gutter

The space between columns of text, or the inside margins between two facing pages.

Halftone dots

Tiny dots of varied size that appear within printed images. Halftone dots are usually too small to be seen without magnification and, when viewed by the unaided eye, result in gradients of value that give form to the content of images and illustrations.

Helvetica

A sans-serif typeface developed in 1957 by Swiss typeface designer Max Miedinger and Eduard Hoffmann. Helvetica is used for all of this book's text and appears within most of its illustrations.

Hue

Another word for color.

Icon

An abstract or representational symbol. Icons often appear as part of logos, and are also used as stand-alone graphics within layouts.

Illustrator

An Adobe program that specializes in the handling of vector-based graphics.

InDesign

An Adobe program primarily used to created layouts for both print and the Web.

Inkjet printer

A digital printer that puts colors onto paper through the application of microscopically small dots of ink.

Kerning

The amount of spacing between letters of a word. Lesser amounts of kerning result in letters that are more tightly spaced. Larger amounts of kerning result in letters that are more widely spaced.

Letterspacing

Another word for kerning (see previous entry).

Mute

To lessen the saturation of a color. Cool hues tend toward cool grays when muted; warm colors tend toward either warm grays or browns when muted.

Offset printing

Printing done with traditional printing presses that apply ink to paper using a series of rollers.

Outline

To convert typographic characters into editable vector-based shapes. Outlining is also referred to as *converting to paths*.

Palette

A specific color scheme applied to a layout or an image.

Pathfinder operations

A selection of highly useful shape-altering operations offered through Illustrator and InDesign.

Photoshop

An Adobe program designed to enhance and modify pixel-based digital images. Many art professionals also use Photoshop to create illustrations.

Press check

The opportunity for a designer and/or client to inspect a printed piece as it is being run. Press checks provide the final opportunity to manage the quality of a printed piece.

Process color printing

Printing done on an offset press using CMYK inks. (Also called *process printing*.)

Reverse

To allow an element of a printed piece (type, linework, decorations, and the like) to appear as the paper color within areas of ink coverage. White type, for example, has been reversed when it appears within an area of black or colored ink.

GLOSSARY

RGB

An acronym for *red, green,* and *blue*—the primary hues of the light-based spectrum of color.

Sans serif

Typographic families with characters that do not feature serifs. Also see *Serif*.

Saturation

The intensity of a hue. A fully saturated hue is a color in its most intense and pure state. Muted versions of hues have lesser levels of saturation.

Screen

A halftone pattern that ranges in density from 1% to 99%. Printing inks can be lightened by printing them as screens.

Screen-build

When two, three, or all four of the CMYK colors of process printing are applied on top of each other— each as a specific screen density—to produce specific colors.

Serif

The rectangular, tapered, pointed, rounded, straight, arched, thin, thick, or blocky shape(s) projecting from the end of the strokes of a serif typeface's characters.

Spot color

Ink colors that are premixed prior to being added to an offset printing press. Spot colors are usually selected from printed or on-screen guides offered by companies such as Pantone.

Static spacing

When the spacing between and around the elements of a layout are relatively repetitive and similar. Also see *Dynamic spacing*.

Tangent

The very point at which any two shapes are (or are very nearly) meeting—without overlapping.

Target audience

The specific demographic being aimed for with a commercially purposed work of design or art.

Thumbnail sketch

A sketch—usually small and quickly drawn—that represents an idea for a layout, logo, illustration, or any other work of design or art.

Typeface

A specific family of typographic characters, such as Helvetica or Garamond. Most people use the words *typeface* and *font* interchangeably.

Value

The darkness or lightness of a color on a scale that goes from near white to near black.

Vanishing point

The exact point at which parallel lines—when seen in perspective—appear to converge.

Visual hierarchy

The apparent visual priority of a composition's elements. A strong sense of hierarchy occurs when one element of a composition (a layout's headline or a photograph's main subject, for example) clearly stands out above the piece's other visual components.

Visual texture

A freeform or geometric repetition of abstract or representational shapes (best defined through actual examples, as seen on page 102).

Warm gray

A gray with hints of brown, yellow, orange, or red. Also see *Cool gray.*

Warm hue

Colors that tend toward yellow, orange, or red. Also see *Cool hue.*

WYSIWYG

Acronym for *what you see is what you get.* WYSIWYG is often mentioned in regard to the elusive goal of matching on-screen hues with printed colors.

Index

INDEX

236

INDEX

INDEX